MONDRIAN

Great Modern Masters

Mondrian

General Editor: José María Faerna

Translated from the Spanish by Alberto Curotto

CAMEO/ABRAMS

HARRY N. ABRAMS, INC., PUBLISHERS

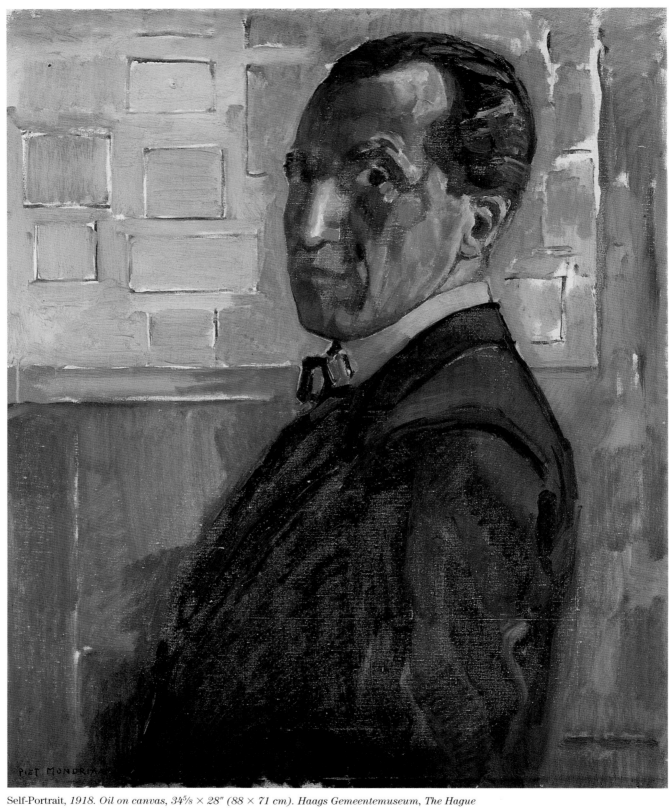

Self-Portrait, *1918. Oil on canvas, 34⅝ × 28″ (88 × 71 cm). Haags Gemeentemuseum, The Hague*

Mondrian's Geometric Utopia

In the second decade of the twentieth century—a period of pervasive unrest—a number of artistic propositions emerged in European intellectual circles. Stemming from very different philosophical positions, these propositions were all based on a faith in the transforming power of art, as well as on a militant opposition to traditional artistic forms. This attitude of rejection—resulting from a natural evolution of taste and, even more, from widespread social instability—was reinforced by the belief that the new society destined to arise from the current conflicts would need a radically different type of art. In this arena, one that was conducive to utopian thinking, the Dutch painter Piet Mondrian would make one of the most radical contributions in the history of contemporary art.

The Autonomy of Art

The extreme character of Mondrian's work arises from the conflation of his temperament, molded by a rigid Calvinistic upbringing, and an artistic environment in which abstraction was taking shape as the most logical consequence of the profound changes introduced into art during the last decades of the nineteenth century. Breaking with traditional ideas about pictorial space, the Impressionists had cleared the way for fresh approaches to painting—an instinctual or emotional one and an analytical one. The resulting solutions would eventually make it possible to claim the absolute autonomy of the work of art with respect to the perception of the object in the physical world. Liberated from its dependence on nature, the work of art was free to acquire its own essence, while artists adopted a set of autonomous rules and standards. Mondrian, who came into contact with these issues by way of Cubism, would go much farther in advocating the emancipation of the work of art even from the artist's own subjectivity. In the name of truth—affirming the Platonic tradition that correlates truth and beauty—the Dutch painter adopted as an objective the elimination from art of all elements of "tragedy," a term that Mondrian identified with the unconscious, especially as manifested in any form of expressionism. According to this line of reasoning, the artist must forgo any attempt to affect the viewer emotionally, since the artistic mission, charged as it is with an ethical content, consists in reflecting the harmony of the universe.

A New Idiom

Mondrian's ambitious plan rested on a belief formed by reading the works of the Dutch philosopher Baruch Spinoza. Like Spinoza, Mondrian deemed it impossible to know anything without the intermediary of perception. At the same time, he also believed that perception in itself was not enough and that a speculative process was needed in order to delve into the very essence of things, into the unique and immutable substance that Spinoza identified with the geometrical order. In Mondrian's work, abstraction came thus to acquire an eminently metaphysical complexion.

In straitened circumstances throughout most of his career, Mondrian was obliged to produce commercial paintings of flowers, such as this Chrysanthemum *of 1908, in order to make ends meet.*

When, around 1925, Theo van Doesburg began to paint compositions like this one, with diagonal lines rather than strictly horizontal and vertical ones, Mondrian withdrew from the group of artists attracted by the ideas put forth in Van Doesburg's periodical De Stijl.

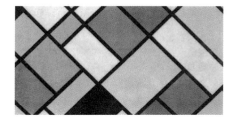

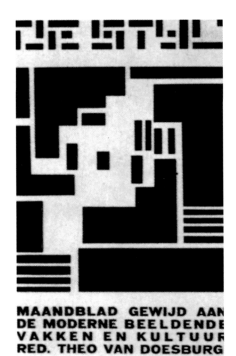

In its first few years—between 1917 and 1920—the review De Stijl *was published with this cover, a work of Hungarian artist Vilmos Huszár.*

This is one of the geometric compositions of Bart van der Leck, an artist who exerted a powerful influence on the development of Mondrian's mature style.

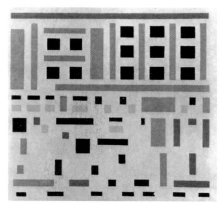

He reasoned that representational art is not capable of generating a universal reality; it only reveals the superficial appearance of things—that is, it merely describes. As a result, the new art—what Mondrian called Neo-Plasticism—had to reject representation, attempting to become instead a vehicle for universal values. In order to attain this goal, it was necessary to achieve a thorough cleansing of the vocabulary and grammar of art, so as to enable it to convey the image of what the painter once defined as the "balanced relation," a vehicle by which "unity, harmony, and the universal can expressively reveal themselves in their diversity, multiplicity, and individuality." Under the influence of the dualistic tenets of Dutch Theosophist M. H. J. Schoenmaekers, Mondrian attempted to attain such a balanced relation by articulating an artistic language based on the opposition of horizontal and vertical lines and non-colored planes—the immutable or spiritual element—on the one side, and, on the other, the variable or natural element introduced by the proportions between the planes and the relations between the three primary colors as well as between colors and non-colors.

The Doors of Perception

Behind this cold, logical program, which constitues the core of Neo-Plasticism, there lies a strong ethical motivation—one that was shared by almost every other modern avant-garde movement—namely, the artists' impulse to take their share of responsibility in the transformation of the social order. For Mondrian—who dedicated one of his writings "to the man of the future"—works of art were meant to act as "doors of perception." They had to contribute to the personal enrichment of the viewer, whenever that person was not in a position to enjoy life to its fullest. Mondrian's notion of the transience of the artistic activity is especially evident in his statement: "Being nothing but an artifice, inasmuch as life is devoid of beauty, art is destined to disappear as life gains increasingly more beauty. . . . Nowadays art is of extreme importance since it is necessary to prove in a physical manner, that is to say directly and independently of our individual conceptions, the laws that can determine the development of a truly human life."

The Social Function of Art

The utopian qualities of Mondrian's work made it an easy target for the imputation of failure with which the entire avant-garde was charged, once the distance between its grand ambitions and its effective results became clear. For example, far from transforming the status quo, modern art actually sanctioned it, by letting itself be assimilated into the market it had rejected. This process of assimilation was especially evident in the case of Mondrian's work since, on account of its formal simplicity, it easily lends itself to all sorts of trivialization. Nevertheless, as Mondrian was well aware, an artwork's social effectiveness is exposed to countless forms of mediation and it can only work in an indirect manner. In his writings, Mondrian repeatedly said that the artist's function is indeed to participate with his creations in transforming society, but he also warned that such transformation is a subterranean one, one that is barely perceptible and whose value can only be appreciated in the long term. By giving shape to the icons of the society of the future—as Mondrian liked to say—creative artists, acting as visionaries, can suggest the way by which a fuller life can be attained.

Piet Mondrian/1872–1944

Pieter Cornelius Mondrian—he shortened his name upon his arrival in Paris in 1912—was born in 1872 in the Dutch town of Amersfoort. His artistic talent was fostered by his father, a confirmed Calvinist and a schoolmaster, with whom the young Mondrian collaborated in a series of historical paintings with a moralizing aim. In spite of this initial support, Mondrian was confronted with harsh opposition from his family when he decided to give up his career as an art professor and devote himself entirely to painting. In 1892, Mondrian enrolled at the Academy of Fine Arts in Amsterdam and entered that city's artistic circles. During the same period, he came into contact for the first time with esotericism, most notably with Theosophy, which would lead to his gradual estrangement from the Calvinist faith. In those years, he also began to earn a living by executing copies of the paintings at the Rijksmuseum, as well as other works on commission. For the better part of his life Mondrian continued this practice—much criticized by some of his peers—maintaining a radical, and therefore hardly commercial, creative activity and at the same time producing hack works as a means of subsistence.

A photograph of Mondrian at thirty-five, when the painter cultivated a bohemian look that he would later relinquish completely.

A Rapid Evolution

Mondrian's earliest pictures, mostly landscapes, clearly show the influence of his uncle, Frits Mondrian, also a painter. Around 1907, however, in the wake of his discovery of the works of such artists as Vincent van Gogh, Kees van Dongen, and Edvard Munch, Mondrian's painting underwent a crucial transformation. The soft colors of his earlier works, a reflection of the damp and misty Dutch countryside that they represent, gave way to a palette of arbitrarily applied pure colors. Mondrian was now rendering familiar themes with an antinaturalistic treatment that fully justifies comparison with the work of the German Expressionists. Mondrian's methodical disposition, however, was thoroughly antipathetic to any show of emotion. Instead, he was attracted by Luminism, as Divisionism was known in Belgium and the Netherlands. Between 1908 and 1910—while staying in the Zeeland town of Domburg, where the painter Jan Toorop was then living with a small community of young artists—Mondrian did indeed adopt Luminist principles; however, this was a brief episode in the artist's career, and at the end of the first decade of the new century Mondrian's work underwent yet another transformation. In 1909 he joined the Dutch Theosophical Society, and the Symbolist nature of this new style reflects the culmination of his interest in esotericism.

The conventional quality of Mondrian's early work is apparent in this black chalk drawing, Young Woman Writing, *which he executed in 1890, at about the age of eighteen.*

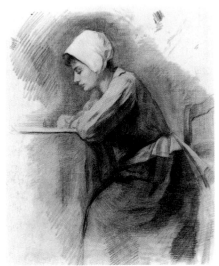

Toward Abstraction

Mondrian's short-lived Symbolist period ended in 1911, when his discovery of the works of Picasso and Braque interested him in Cubism. He moved to Paris, which was then a mecca of the artistic world. In the French capital, working in a studio in the rue du Départ (which he kept until 1935), Mondrian developed his own individual notion of Synthetic Cubism, exhibiting a definite tendency toward full abstraction. In 1913, his work began to receive some recognition: the French poet Guillaume Apollinaire, a notable advocate of Cubist painting, praised the originality of the work that Mondrian showed at the Twenty-ninth Salon des Indépendants;

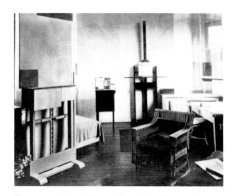

The sobriety of Mondrian's studio in Paris was legendary: bare walls, scant furnishings, and one single allusion to the world of nature, an artificial flower painted white.

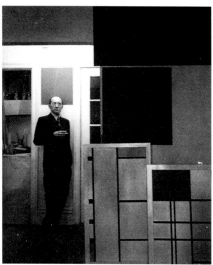

This photograph, taken two years before Mondrian's death, shows the painter surrounded by his own works in his New York studio on First Avenue.

that same year, the artist entered into a contract with the Kröller-Müllers, a family of famous industrialists, whereby he agreed to produce a certain number of paintings yearly in exchange for a stipend. The outbreak of World War I caught him visiting his ailing father in the Netherlands, and he was obliged to remain there for the four-year duration of the war. During this period of exile from Paris, Mondrian established the foundations of his mature production. This important development took place under the influence of a number of personalities. One of them was the Theosophist and mathematician M. H. J. Schoenmaekers, whose writings contain some elements of Mondrian's own aesthetic, such as the importance of verticals and horizontals and the exclusive use of the three primary colors. The painter's decision to abandon the Cubist aesthetic was also hastened by his crucial encounter with the abstract geometrical shapes and large color fields of Bart van der Leck's paintings. In the same period, Mondrian met the artist Theo van Doesburg, who gave Mondrian the opportunity to air his own ideas in the journal that he was planning to publish.

De Stijl

Van Doesburg's journal *De Stijl* (The Style), was first issued in 1917. Its name became a label for the group of artists who had been attracted by the ideas advanced between its covers. In *De Stijl* Mondrian published his first theoretical work of some importance: "De Nieuwe Beelding in der Schilderkunst" (Neo-Plasticism in Painting). The year 1917 also saw the inception of a process of simplification in his painting that, around 1920, would lead to the first of his characteristic grids of orthogonal lines, enclosing rectangles of primary colors. In 1919, the artist returned to Paris. Gradually, Mondrian's work began to be appreciated, and in 1922, on the occasion of the painter's fiftieth birthday, his friends organized a retrospective in Amsterdam. Three years later, the artist put an end to his association with Van Doesburg, when the latter adopted the diagonal line in pursuit of what he labeled Elementarism. This Mondrian regarded as a betrayal of their shared aesthetic principles.

The Exile

In the second half of the 1920s, the painter's fame grew progressively greater; he was invited to show his work in countless exhibitions, including those of Cercle et Carré and Abstraction-Création, two groups of which he had been a member. In addition to his painterly activity, Mondrian continued to set forth his ideas in essays, such as "Art and Life" (1931) or "Plastic Art and Pure Plastic Art" (1937). In 1938, the threat of a new war led him to move to England, where he remained for two years. In 1940, Mondrian decided to leave Europe for New York. The move precipitated a change in his painting. He had already begun to suppress black in his pictures during the previous decade; now the balance between color and non-color tipped overwhelmingly in favor of color. In his famous American works *Broadway Boogie-Woogie* and *Victory Boogie-Woogie* (plates 62, 63), the black bars have disappeared, loosing disciplined streams of color patches across the white background. *Victory Boogie-Woogie* was left unfinished when Mondrian died of pneumonia in February 1944. The great posthumous retrospective held in New York at the Museum of Modern Art the following year underscored Mondrian's influential role in the history of contemporary art.

Plates

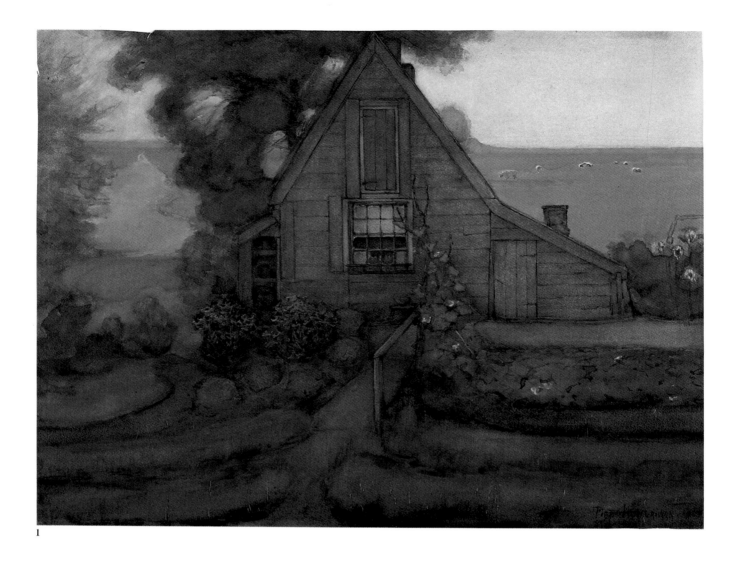

1

The Dutch Landscape

It is surprising that the painter who became one of the most radical innovators in the history of modern art continued to practice a relatively conventional type of painting well into his thirties. Mondrian began his career under the influence of his uncle, Frits Mondrian, who painted in the style of the Hague School, a group of artists who had settled in the capital of South Holland province around the middle of the nineteenth century. Like the Barbizon School artists in France, the painters of the Hague School distanced themselves from academic art and its rules. Discarding ambitious mythological and historical themes, they focused instead on such motifs as the landscape of the Dutch countryside or the rustic interiors of its farms. In the Netherlands, where no local version of Impressionism developed, this school of painting continued to have a following well into the last decades of the nineteenth century. Mondrian was one such emulator, and among the recurrent themes of his earliest works one finds placid meadows with grazing cattle, windmills, and farms painted in earthy tones that blend in with those of the surrounding woodland.

1 Solitary House, *1898–1900. Widespread opinion assigns this painting to the turn of the century, but certain authors, such as Michel Seuphor, feel that Mondrian's antinaturalistic use of colors and his geometric treatment of the house imply a later date of execution, approximately between 1906 and 1908.*

2 Beech Forest, *c. 1898–99. As with the preceding work, there is disagreement about the date of this watercolor. According to some, the exaggerated perspective, the barely realistic color scheme, and the cropping of the trees—reminiscent of a framing technique often adopted by Edvard Munch—suggest a date in the first decade of the twentieth century.*

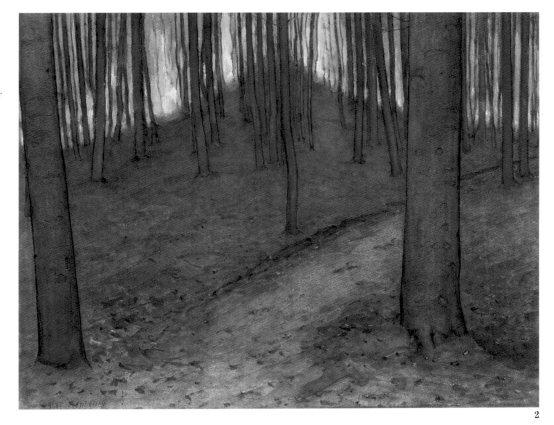

2

3

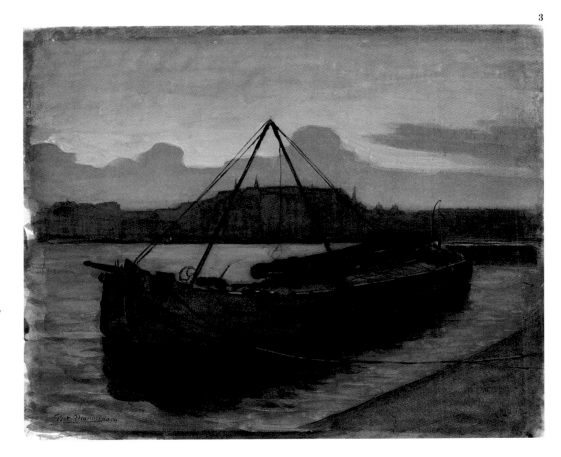

3 Boat on the Amstel at Sunset, *1900–1902. Following the example of the Hague School artists, Mondrian painted many of his early works outdoors. In these pictures, the artist made abundant use of earthy colors and muted tones, apparently unaware of the plein-air paintings of the French Impressionists, with their characteristically high-key palette.*

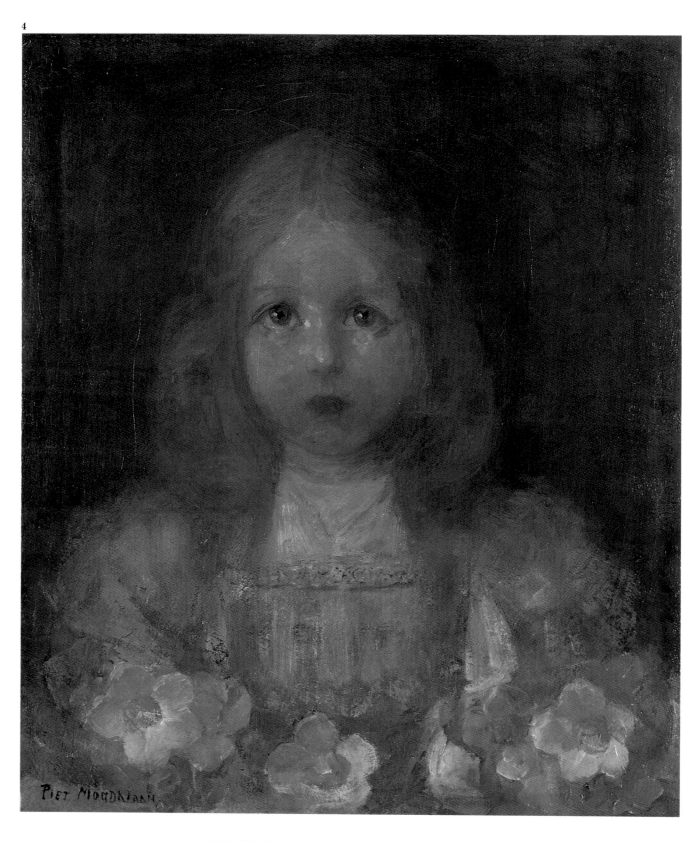

4 Little Girl, *1900–1901. This work is exceptional in more than one respect. First, it is a portrait—a type of picture Mondrian rarely painted. At the same time, the loose brushwork and the use of color are evocative of a later phase in the artist's career. Most unusual is the rather melodramatic air that pervades the painting; the Dutch artist was little given to displays of emotion in his work.*

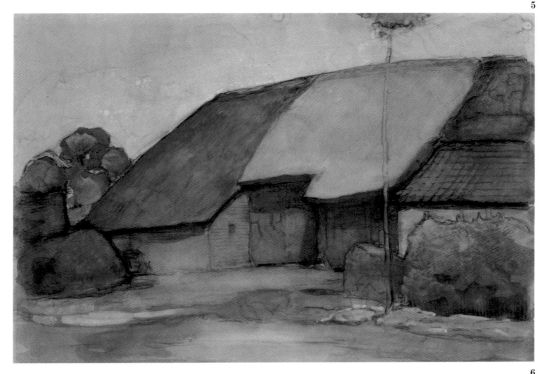

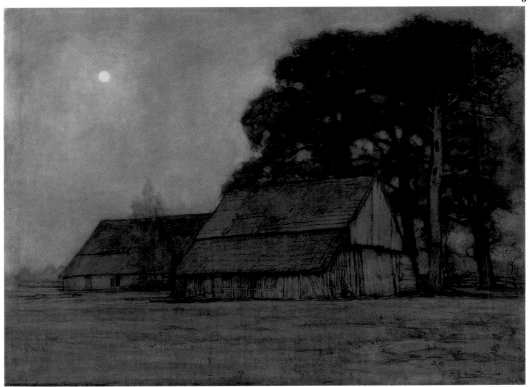

5, 6 Nistelrode Farm, *1904–5. A Stable at Sunset, 1906. These two*
watercolors are evidence of the artist's fondness, in the early
stages of his career, for themes of the Dutch countryside and its
farms. In reference to works such as these, Mondrian once wrote:
"In painting landscapes and houses I always preferred either
overcast, somber weather or a harsh sunlight, that is to say, when
the objects are all but erased by the atmosphere. . . . I have never
painted these things in a romantic manner; from the very
beginning, I was always a realist."

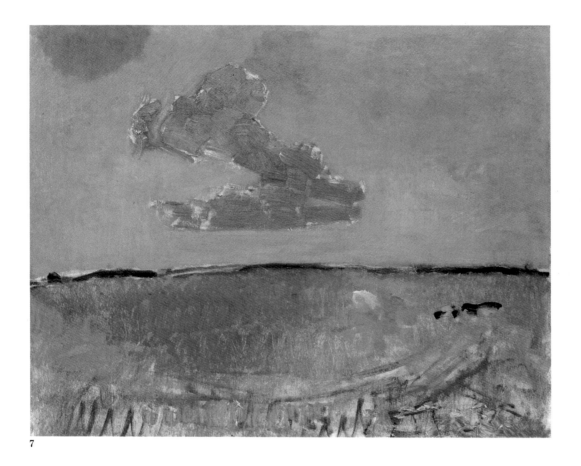

7

Setting Color Free

The earliest indication of the rapid change that Mondrian's work would undergo in the second decade of the twentieth century became evident around 1907. The transformation was hastened by his association with avant-garde Dutch painters Jan Sluyters, a Post-Impressionist, and, above all, Jan Toorop, a Symbolist. Mondrian described the reasons for his dissatisfaction with his earlier work as follows: "The first thing that needed to be changed in my painting was color. I abandoned natural colors in favor of pure colors. I had come to the conclusion that the colors of nature cannot be reproduced on a canvas. I could instinctively feel that painting as a form of art had to devise a new way to express the beauty of nature." At first, the painter's newfound boldness in the use of colors was reminiscent of the Expressionist movements that were then emerging in France and in central Europe; later, however, between 1908 and 1910, Mondrian would also experiment with Luminism, and the knowledge that he gained brought the artist closer to what would be his mature style. Luminism—a local version of Divisionism, the systematic means of achieving greater luminosity in painting that Seurat and Signac had developed two decades earlier in France—was part of the first attempt in the history of modern art to objectify artistic practice by submitting it to immutable rules. This cerebral type of approach appealed to Mondrian. Later in his career, the artist would formulate a set of rules for achieving absolute equilibrium, which he equated with perfection, in art.

7 Landscape with Red Cloud, *1907. Here, the landscape is merely a pretext for creating a nearly abstract composition. Both the violent use of colors and the vigorous execution, with broad brushstrokes thick with impasto, are evidence that Mondrian had definitively abandoned the artistic idiom of the Hague School.*

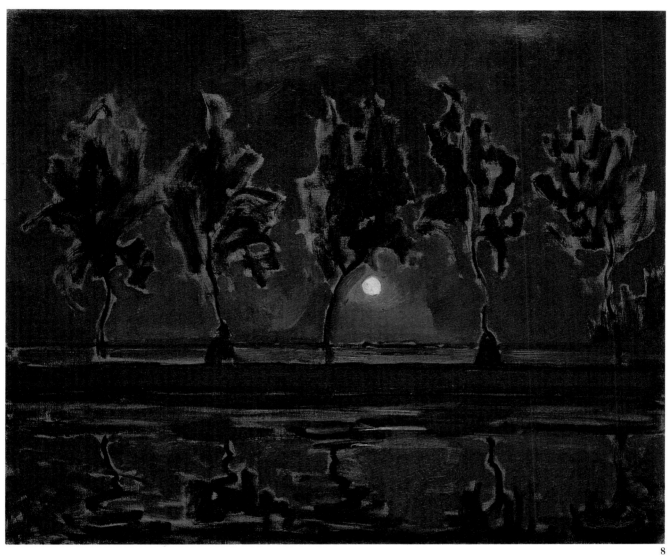

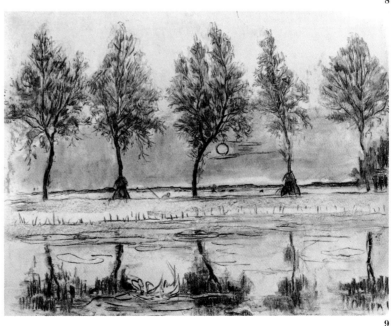

8, 9 Trees on the Gein: Moonrise, *1908.*
Trees on the Gein: Moonrise, *1907–8. The*
apparent spontaneity of the finished oil
(above) is belied by the charcoal drawing
on which it is based (below). Details in the
background and foreground of the drawing
have been completely eliminated from the
oil, leaving only the striking outlines of the
five trees, which seem whipped by the heat
of red sky and water ignited by a hot
yellow moon. This comparison offers a
fascinating glimpse into the creative
process of an artist who achieved stunning
effects by means of simplification and
reduction.

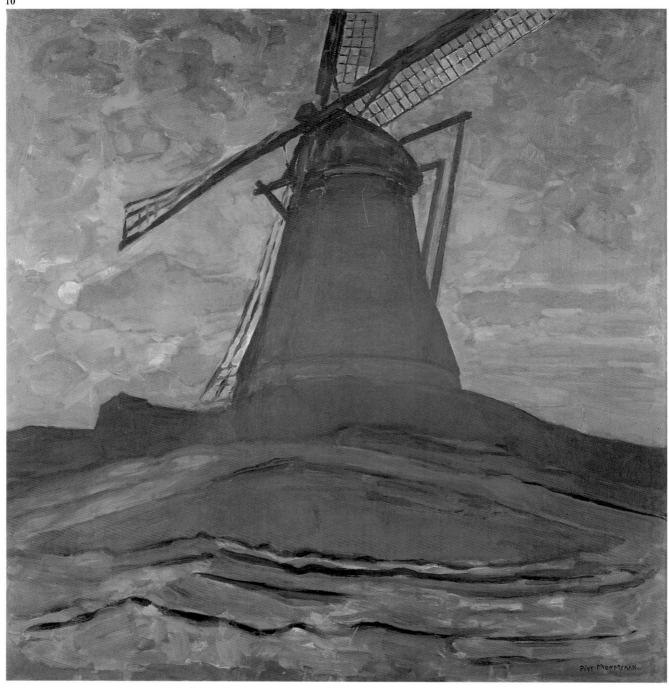

10, 11, 12 Windmill, *1907–8.* Windmill at Sunset, *1908.* Windmill in Sunlight, *1908. Mondrian always exhibited a strong predilection for the windmill motif. In his theoretical work "Natural Reality and Abstract Reality" (1918–19), the artist praised the beauty of the image of a windmill silhouetted against the bright, starry night sky. The painter was fascinated by the imposing mass of a windmill seen close up and, above all, by the cross shape of its four sails, whose orthogonal arrangement is, in the artist's own words, "the foundation of everything." Here, the windmill theme is rendered in three different ways. The first two works emphasize the massive quality of a windmill. In the third, the use of a Divisionist technique—juxtaposing areas of pure pigment so that they combine with great brilliance in the eye of the viewer— enabled the painter to negate the solidity of the structure, which seems to be ablaze in the intense sunlight.*

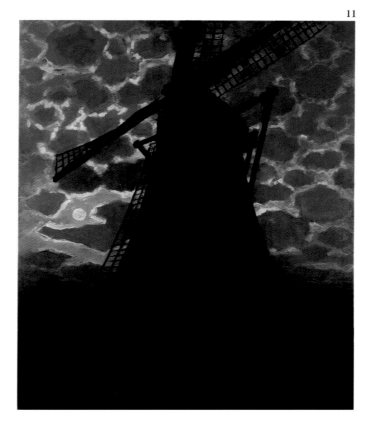

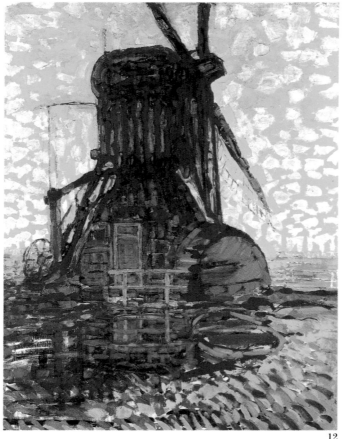

13

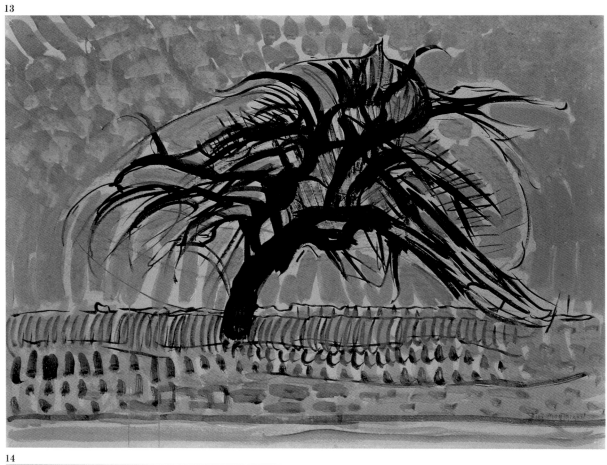

14

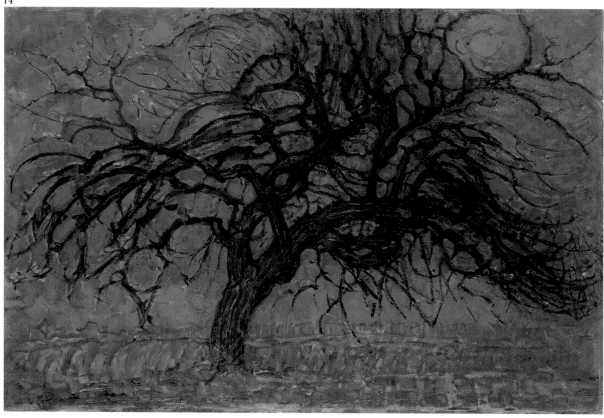

13, 14 Blue Tree, *c. 1908*. Red Tree, *1908. In these two paintings, Mondrian carried out an "abstraction" in its most literal sense— that is to say, he separated out the essential features of the image of a tree, discarding every incidental element. Around 1917, having severed all ties with objective representation, the painter avowed his predilection for leafless trees, whose articulated lines and planes can be perceived immediately and distinctly.*

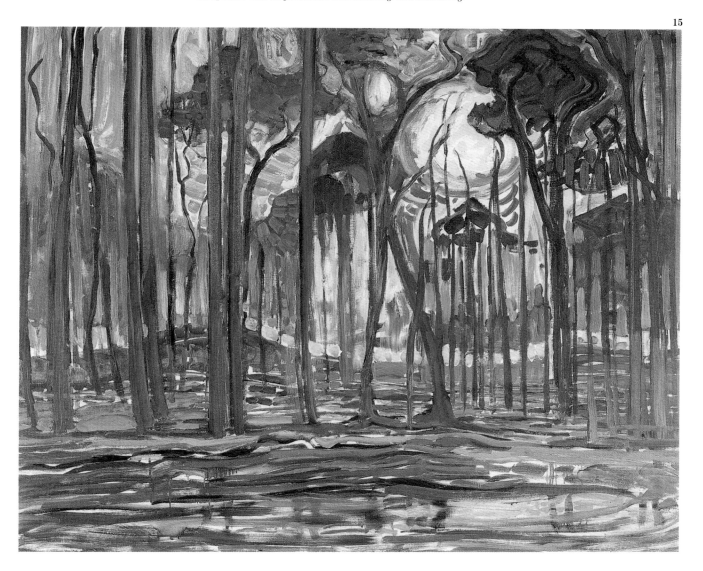

15 Woods near Oele, *1908. The works that Mondrian painted during this year constitute an exceptional chapter in his artistic evolution. The dramatic palette and the expressive brushwork— reminiscent of the work of Edvard Munch or the members of the German group Die Brücke in the same period—convey a degree of sensibility rare in Mondrian's cerebral aesthetic.*

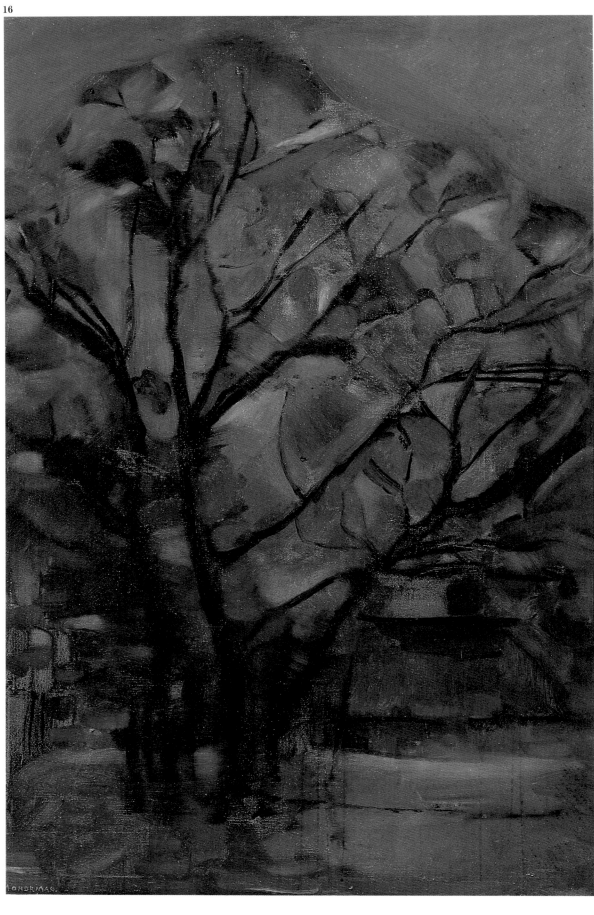

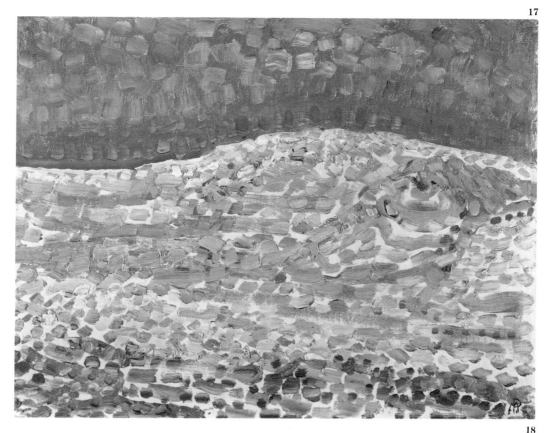

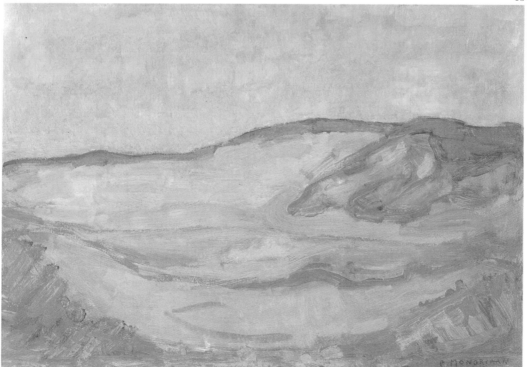

16 The Tree, *1908. If this work was indeed painted in 1908, as is often maintained, this canvas actually anticipates the Divisionist experiments that Mondrian undertook the following year. Some features of the painting certainly suggest a date of two or three years later. The faceted color patches or the unequivocally geometric process to which the composition is subjected bespeak the influence of Cézanne and the beginning of Mondrian's Cubist phase.*

17, 18 Dune II, *1909.* Dune IV, *1909. These two works on the same motif are evidence of the speed with which Mondrian was moving ahead in his search for a more personal expressive vehicle. While Dune II is a good example of the brief Luminist episode in the artist's career, Dune IV—painted only a few months later—bespeaks his renewed interest in the use of lines and already portends his Symbolist phase.*

Symbolism

During the course of Mondrian's artistic development, as has been aptly pointed out by the artist's biographer Michel Seuphor, "Calvinism was first engulfed by Theosophy, and then Theosophy was absorbed by Neo-Plasticism, which was left with the task to express it all without words." Toward the end of the first decade of the twentieth century, Mondrian's interest in the esoteric gave rise to a series of paintings that bespeak the artist's intent of capturing the ultimate essence of things. An attitude was taking shape behind this new interest that would subsequently characterize the painter's mature production: according to this view, the artist is a kind of initiate, capable of sensing the invisible and of presenting it in a more accessible form. This belief can elucidate something that Mondrian wrote in 1917: "Until today, the various ages of civilization have come into existence by the intermediary of a single individual (positioned above and on the margin of the community at large) who was able to quicken in the masses a sense of the universal. Initiates, saints, and gods have brought to the people (as if from outside) the recognition of the universal, and with it an understanding of stylistic purity."

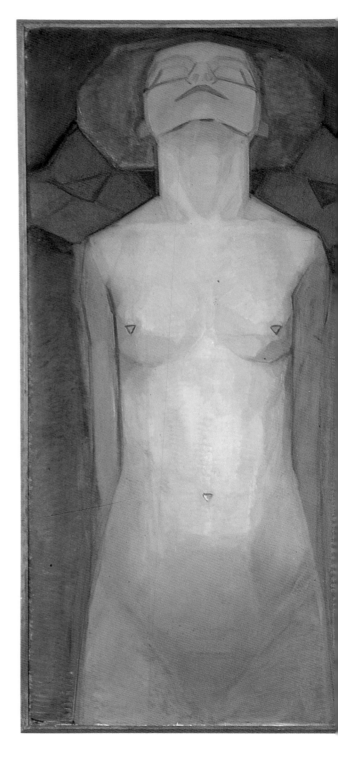

19 Evolution, *1910–11. This triptych offers rather theatrical evidence of Mondrian's esoteric interests. The panoply of symbolic images— Stars of David, mystical triangles, and hexagons—endows the work with a literary content that the painter, in his mature writings, would subsequently disown as an abomination.*

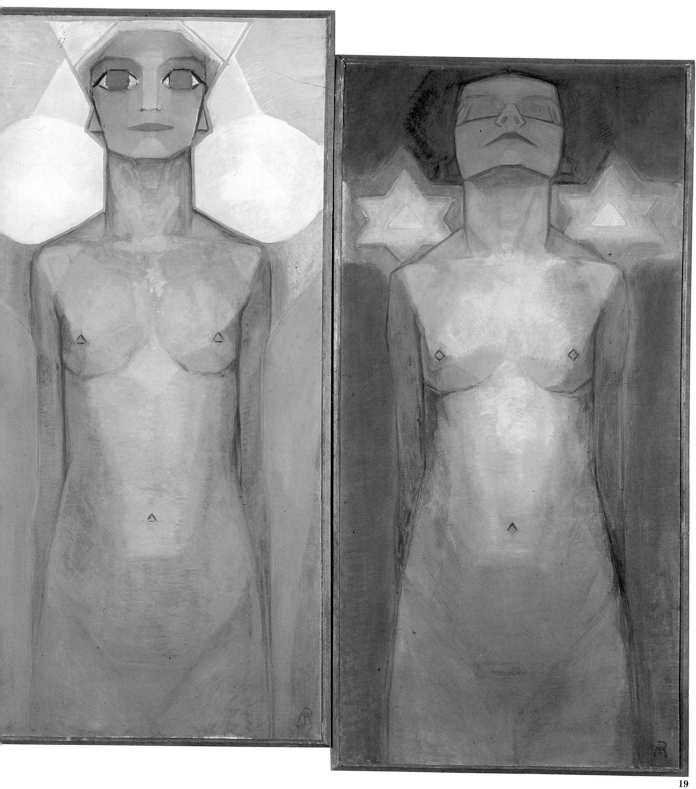

19

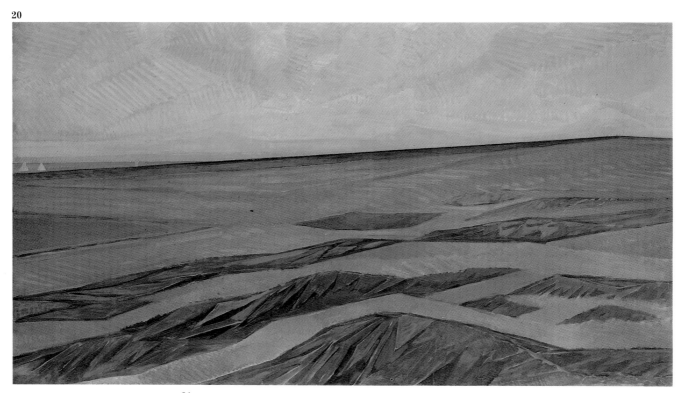

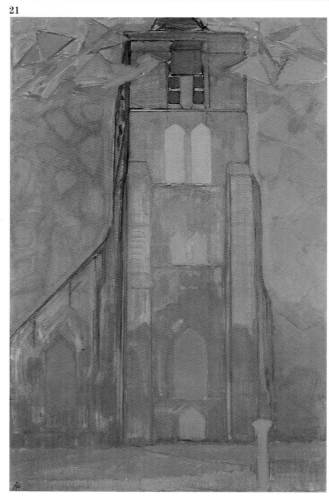

20 Dune Landscape, *1911. A recurrent theme in Mondrian's work, whose different renditions illustrate the progress of his artistic evolution, dunes appear again in one of the works from his Symbolist period. For Mondrian, the horizontal was expressive of the feminine principle in life. With no landmarks to alter their dramatic blue monotony, the endless, undulating horizontal lines of the dunes suggest the origins of life itself.*

21, 22 Church at Domburg, *1910–11. Red Windmill at Domburg, 1911. In this phase of the artist's career, red and blue are the prevailing colors in his paintings. In fact, they are virtually the only ones. Familiar motifs, such as the tower of the church at Domburg— the town in Zeeland where Mondrian built a fruitful relationship with the Dutch Symbolist artist Jan Toorop—or the ubiquitous windmill, are reinterpreted in this specific chromatic key. In these two paintings, the adoption of a close-up view enables the artist to emphasize the verticality of the two structures.*

23

The Cubist Way

Mondrian discovered Cubism at an exhibition of works by Picasso and
Braque that was held in Amsterdam in October 1911. This experience
affected the artist deeply: within a few months of visiting the show, he
moved to Paris, where he assimilated the principles of the new school so
quickly that the following year, in March, his own work was exhibited
alongside that of other Cubists at the Twenty-eighth Salon des Indépen-
dants. Soon, Mondrian began to look upon the movement merely as a
road toward abstraction; consequently, he developed a very personal view
of Analytic Cubism, as attested by his disinterest in still lifes—a genre
quite common in the production of other Cubist painters—favoring
instead his own traditional motifs (such as the windmill or the tree). The
inner logic of this process soon led him to sever his ties with Cubism,
since this movement, in the painter's own words, "was not about to accept
the consequences of its own discoveries"—that is to say, it did not advo-
cate absolute abstraction. Around 1913, Mondrian's paintings ceased to
accommodate any reference whatsoever to the world of concrete objects:
composition was reduced to a pattern of orthogonal strokes inscribed
within an oval structure. In the same period, the painter revealed the foun-
dation of his entire aesthetic theory by declaring that the guiding aim
behind such works was nothing else but "the physical expression of uni-
versal beauty."

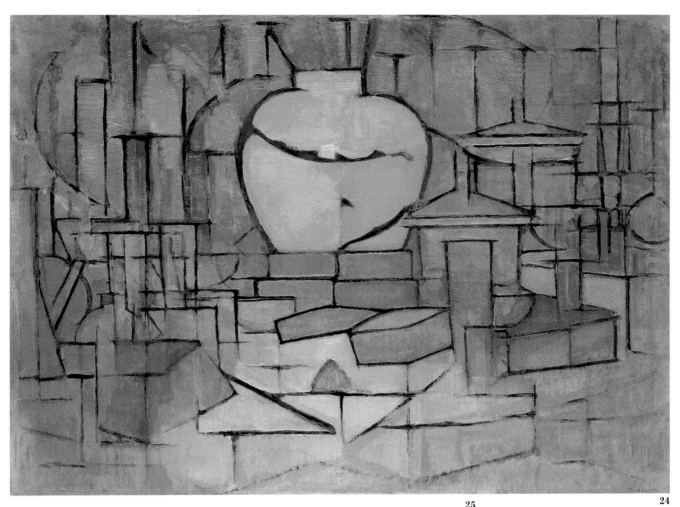

25

24

23, 24 Still Life with Gingerpot I, *1911.*
Still Life with Gingerpot II, *1912. These two
images, painted within the period of a few
months, show how quickly Mondrian
assimilated Cubism. While the first
painting is still indebted to Cézanne, the
second clearly evinces the influence of
Picasso and Braque, in that the number of
recognizable objects is drastically reduced.
In* Still Life with Gingerpot II, *one can only
distinguish the large pot and a few glasses.
Also, in its subdued coloring the later
painting closely resembles the ocher-colored
compositions that the founders of Cubism
were painting during the same period.*

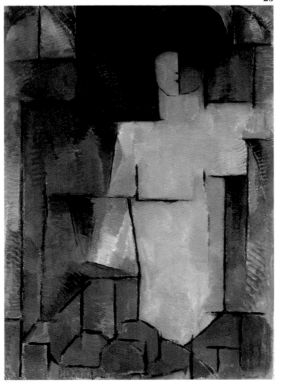

25 Nude, *1912. In Mondrian's work, the
human body occupied a very minor place.
This painting is one of the artist's rare
nudes; the figure's upright position and
hieratic quality relate it to the most
famous of them, the one that appears in the
triptych* Evolution *(see plate 19). Since
Mondrian was working in the Cubist
idiom, this woman's body has dissolved
into a set of geometric planes and lacks
almost every suggestion of three-
dimensionality.*

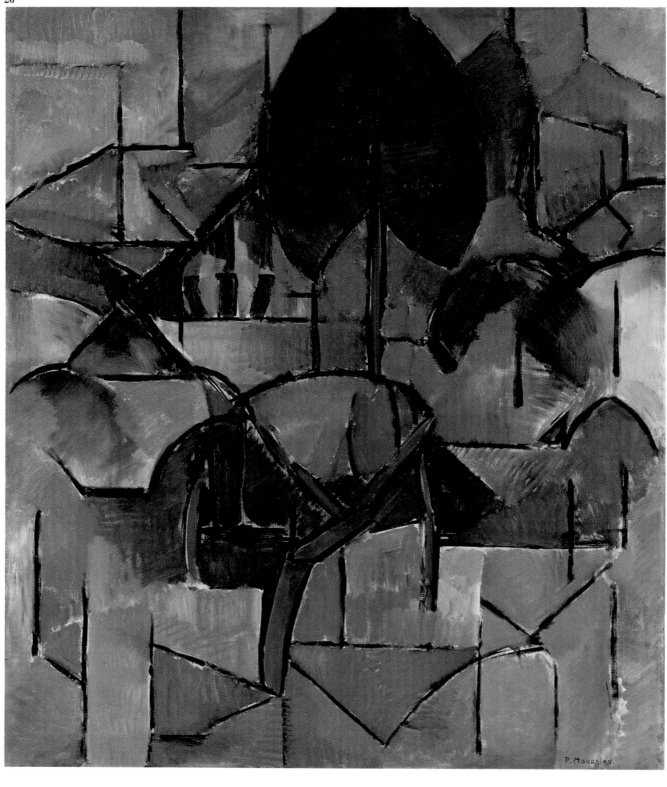

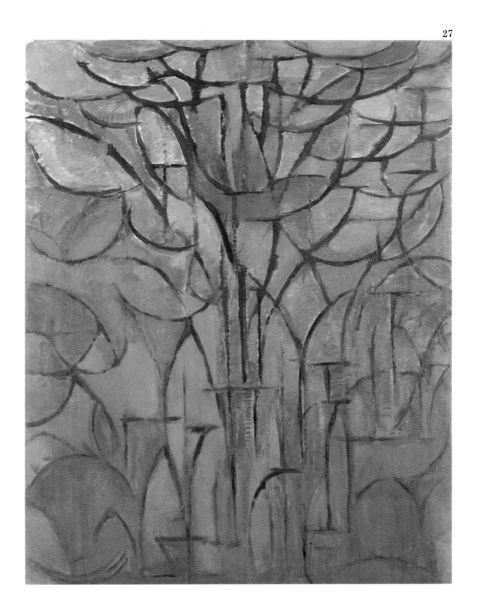

26, 27 Landscape with Trees, *1912.* The Trees, *1912. Mondrian returned to his favorite theme of the tree in a substantial number of Cubist canvases. In* Landscape with Trees, *the artist had not yet severed all ties with representation, and as a result it is still possible to discern the outlines of the trees, although they are in a very schematic form. In* The Trees, *the process of abstraction is almost complete: the structure of the trees is based on a dynamic framework of curved strokes, almost Futurist in feeling, that seems to extend well beyond the physical boundaries of the canvas.*

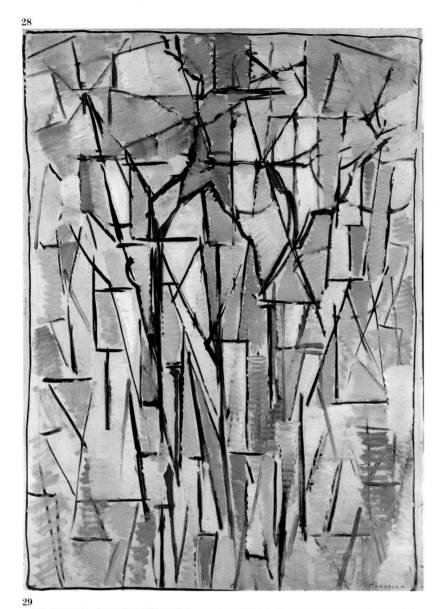

28 Composition Trees II, *c. 1912–13. Here, a reference to the plant world has not translated into curved forms. Having suppressed all traces of representation, Mondrian created a nearly monochromatic composition that is already beginning to exhibit signs of the rigorous geometricizing process that his work would undergo at a later time.*

29

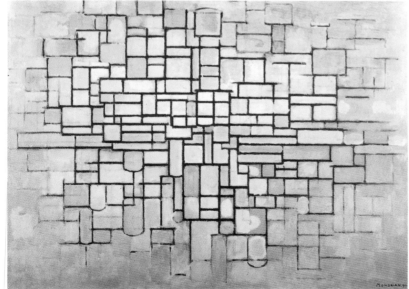

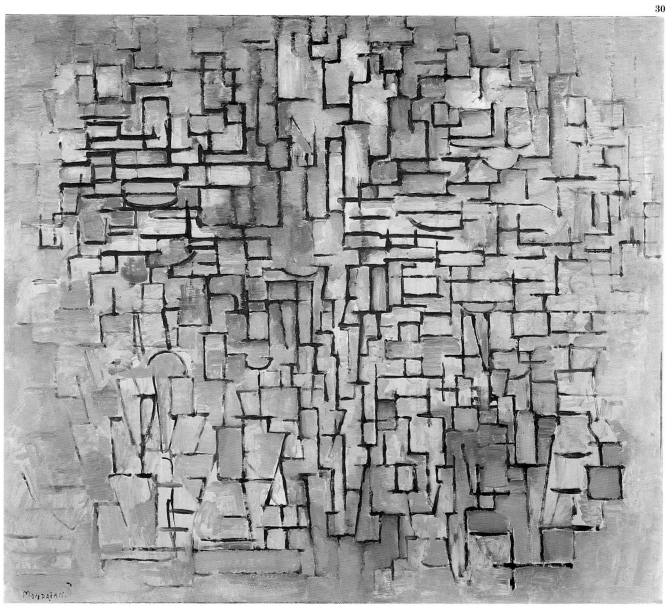

29, 30 Composition in Line and Color, *1913.*
Composition No. VII, *1913. By 1913, Mondrian's
association with Cubism was becoming
progressively looser: the titles of the works illustrated
here—derived from the field of music—underscore
their abstractness. On the other hand, these and
other canvases of 1913 incorporate a more varied
range of colors, which are now contained within
an orthogonal grid.*

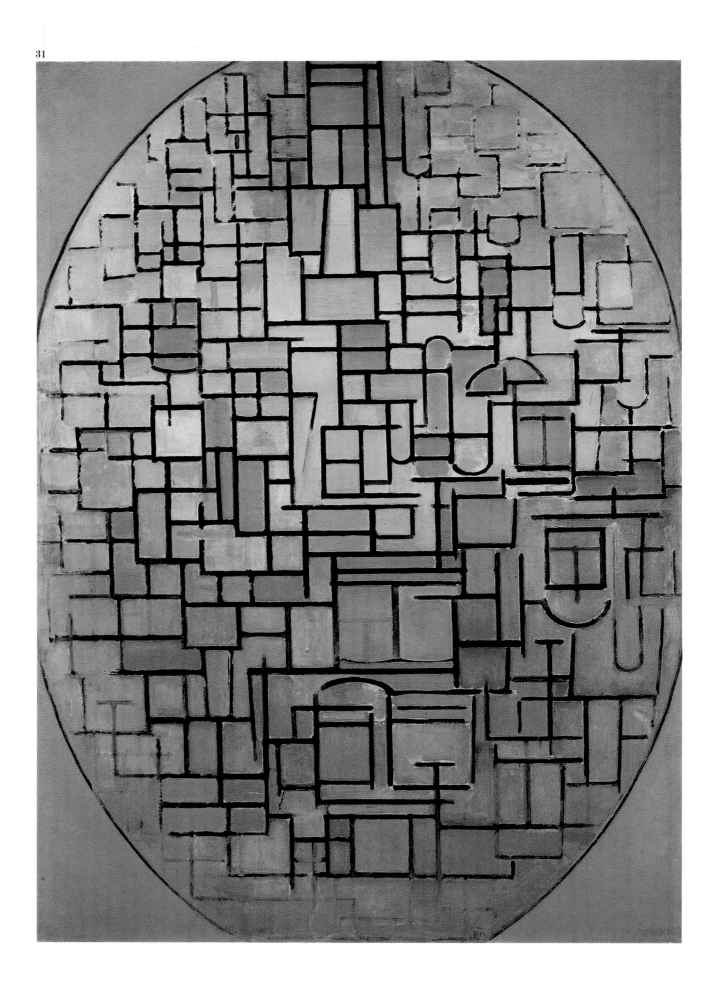

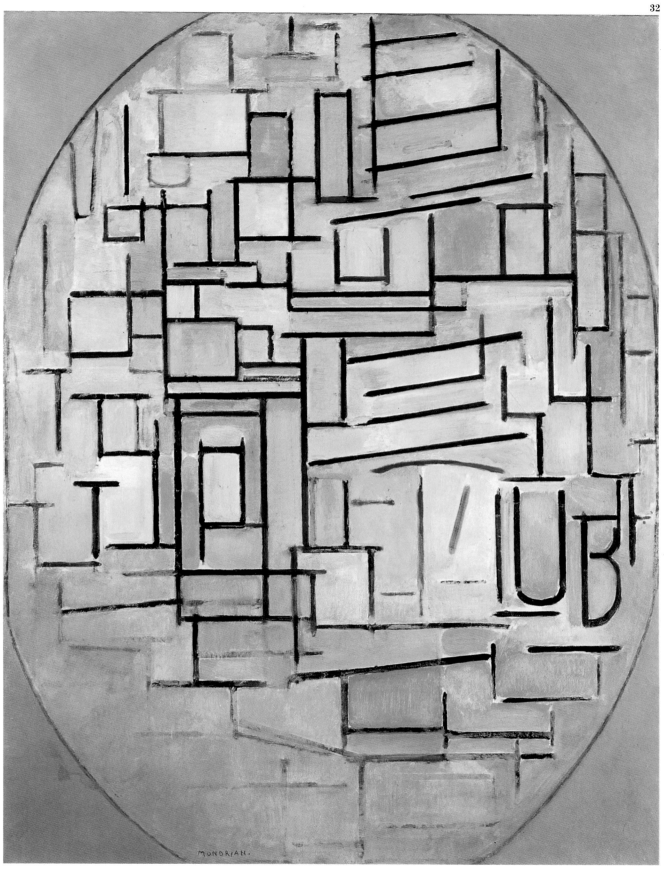

31, 32 Oval Composition III, *1914. Composition in Oval with Color Planes 2, 1914. Around 1914, Mondrian produced a considerable number of compositions in which an oval surrounds a more or less regular grid pattern. In one of his writings from that year, the painter explained such works in these terms: "I believe that by using vertical and horizontal lines according to a conscious construction but without any calculation, guided only by the loftiest intuition, that is, lines subordinated to harmony and rhythm with such elements of beauty—and with the addition, if necessary, of oblique and curved lines—I believe that it is thereby possible to create a work of art that is as strong as it is authentic."*

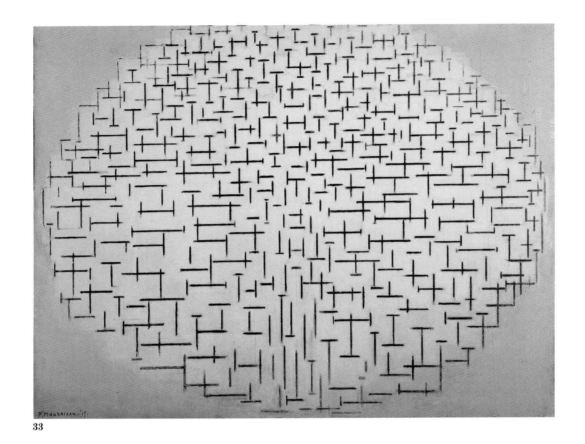

33

Neo-Plasticism

Toward the middle of the 1920s, a number of movements arose that favored a nonobjective type of art, one that would obey a set of independent rules and would, therefore, have no need to refer to the objects of the physical world. In the four years that he spent in Holland during World War I, Mondrian, who came to abstraction by way of Cubism, had been exposed to two essential influences that affected the further development of his artistic career. One was the work of Bart van der Leck, whose stylizations, constructed on blocks of pure colors, would become the guideline along which Mondrian's new style developed. The second influence lay outside the artistic world; it proceeded from the work of M. H. J. Schoenmaekers, a mystic who in a 1915 essay, "The New Image of the World," had written: "The two fundamental and absolute extremes that shape our planet are: on the one hand the line of the horizontal force, namely the trajectory of the Earth around the Sun, and on the other the vertical and essentially spatial movement of the rays that issue from the center of the Sun . . . the three essential colors are yellow, blue, and red. There exist no other colors besides these three." Building on such disparate elements, Mondrian developed a program—painstakingly set forth in the pages of the review *De Stijl*—that conceived of the work of art as a vehicle for expressing the force and harmony of the universe by exclusively physical means.

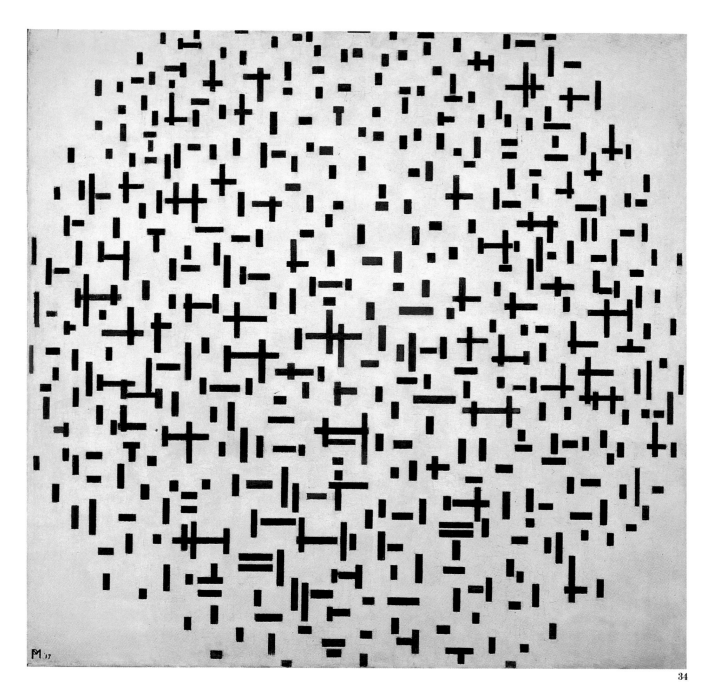

34

33, 34 Composition 10 in Black and White, *1915*. Composition in
Line, *1917. In the Netherlands during World War I, Mondrian
visited the seashore and painted a series of works inspired by the
vibration of the waves breaking against a pier or breakwater.
Years later, the artist had the opportunity to explain these austere
compositions filled with crossed lines: "In surveying the sea, the
sky, and the stars, I had meant to expose their plastic function by
means of scores of horizontal crosses. Struck by the immensity of
nature, I attempted to express its breadth, its tranquillity, its
unity."*

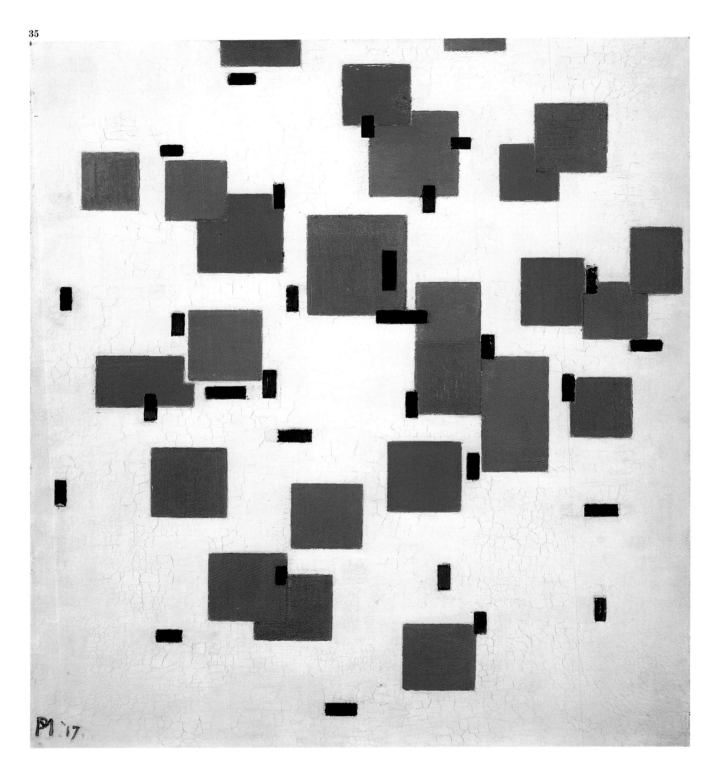

35 Composition in Color A, *1917. In this work, there continue to be references to the theme of the breakwater (see plates 33, 34) even though the crosses are here kept to a minimum. Additionally, a series of small colored rectangles make their appearance. The colored elements are set against a monochromatic background, while the superimposition of some of them may create a vague illusion of depth.*

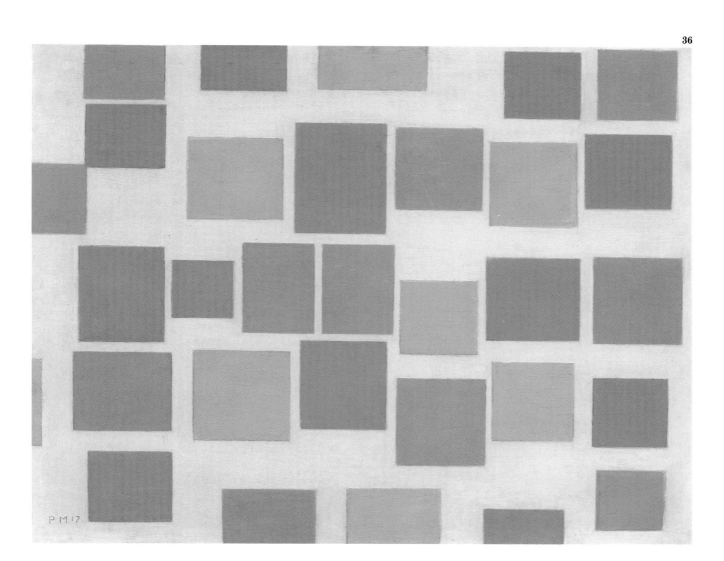

36 Composition with Color Planes 3, *1917. This is
the earliest expression of the Neo-Plasticist aesthetic.
The rectangles do not touch each other, and some
appear to extend beyond the boundaries of the
painting. In a letter dating from the same year,
Mondrian justified his use of mixed tones,
indicating that it was necessary to shape the
viewers' taste little by little: "I use these subdued
colors only provisionally, in accordance with the
current environment as well as the real world;
this, however, does not mean that I do not prefer
pure colors."*

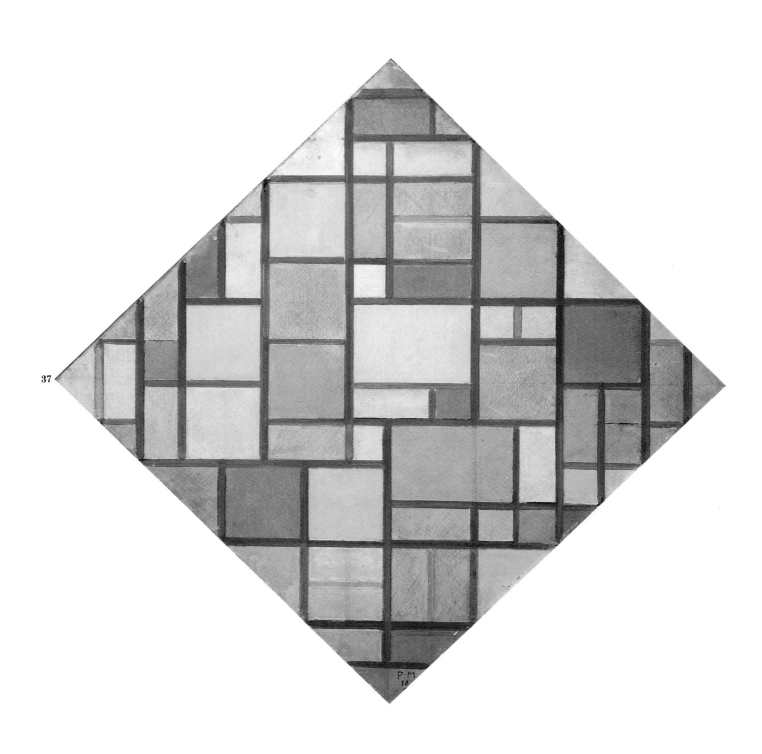

37

38

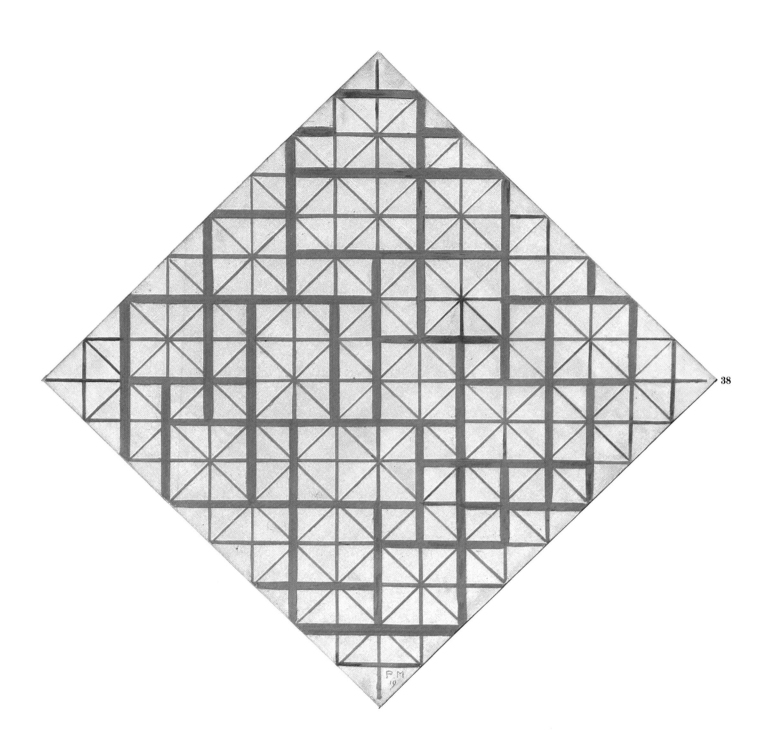

37, 38 Composition with Grid 7 (Lozenge), *1919. Composition with Grid 4 (Lozenge),* 1919. *Mondrian did not always exhibit the aversion to diagonal lines that, in 1925, led to his estrangement from Theo van Doesburg. Seven years earlier, in fact, he himself had experimented in this direction as is attested by the two works illustrated here.* Composition with Grid 7 (Lozenge) *is especially important since, apparently, the painter originally conceived it with the canvas resting on one side. Rather unsatisfied with the result—as he confessed in a letter to Van Doesburg—he then chose to rotate the painting 45 degrees and to present it instead as a diamond-shaped picture, launching a long series of works in this format.*

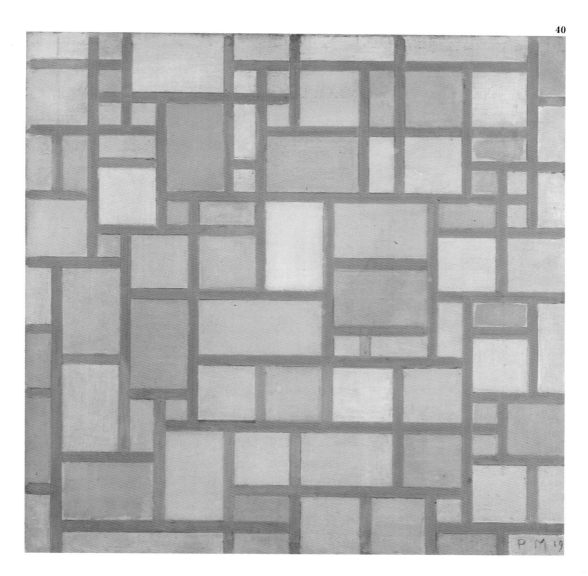

39, 40 Composition with Grid 9 (Checkerboard with Light Colors), *1919. Composition with Grid 6, 1919. These "Compositions" painted shortly before 1920 already reveal the logic behind the process that would eventually lead Mondrian to adopt his most typical mode of expression. In each work, the painter explores one of the two determining aspects of his art by reducing the effectiveness of the other factor as much as possible. Thus, in order to analyze the relationships between colors (plate 39) he controls spatial relations by covering the canvas with a regular grid. To investigate the result of altering spatial relations—the different proportions and sizes of the rectangles that compose the grid—he limits his colors to a very narrow range (plate 40).*

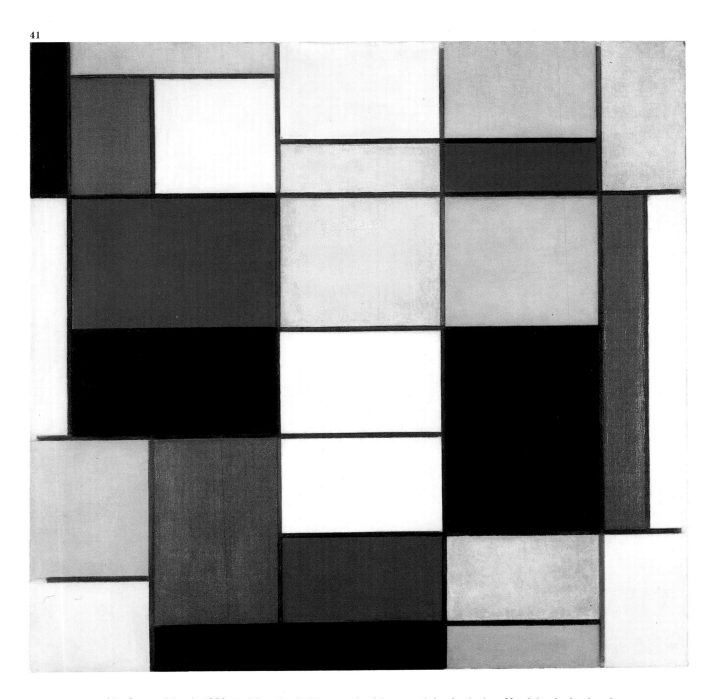

41 Composition A, *1920. At this point in his pursuit of the essentials of painting, Mondrian had reduced his palette to the three primary colors—red, yellow, and blue—and to a series of "non-colors," black, gray, and white; however, he was still uncertain as to the ideal width of the lines that define the grid. After experimenting with a rather fine stroke, he opted for a thicker one, generally traced in deep black, in order to emphasize the separation of the various planes of color.*

42 Composition with Black, Red, Gray, Yellow, and Blue, *1921. Mondrian wrote on the back of this painting "Tableau I" (Painting I), indicating his satisfaction with what he undoubtedly viewed as a perfect work. At the same time, the words reveal the artist's assured conviction that with this picture he had launched the definitive stage of his artistic evolution. The grid pattern has undergone a process of simplification, and each one of the three primary colors appears only once, so as not to conceal the innermost core of his aesthetic: art as a creation of elementary relations—between lines and planes, as well as between colors and non-colors.*

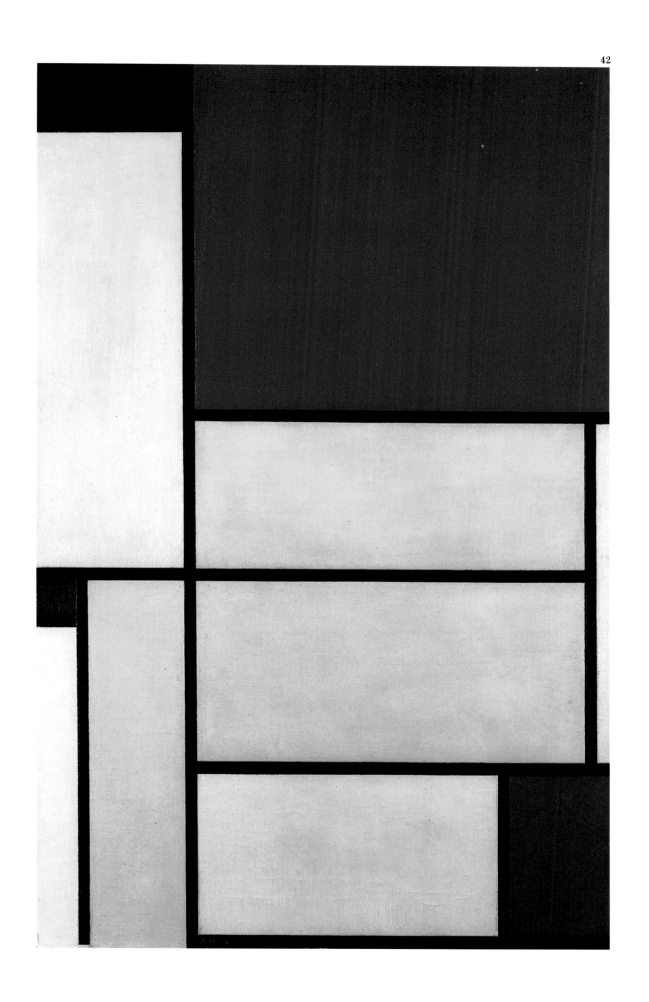

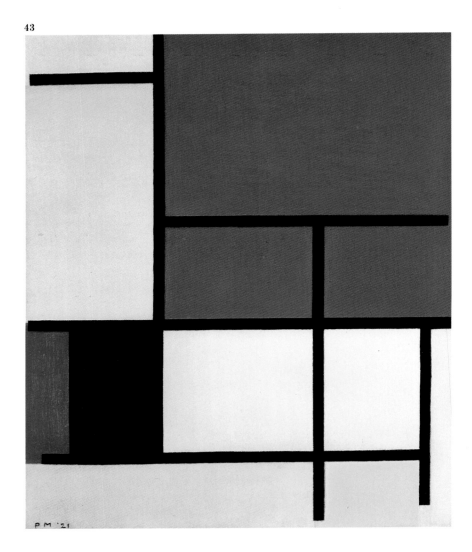

43, 44, 45 Composition with a Large Blue Plane, Red,
Black, Yellow, and Gray, *1921.* Composition with Blue,
Yellow, Red, Black, and Gray, *1922.* Composition with
Blue, Yellow, Red, and Black, *1922. Throughout the
1920s, Mondrian produced variations on the same
basic idea. The similarity of these works dictates a
search for nuances. Thus, it should be noted that the
three canvases illustrated on these pages were
painted before 1923, and that up to that date the
black lines that separate the fields of color did not all
stretch to the edge of the painting.*

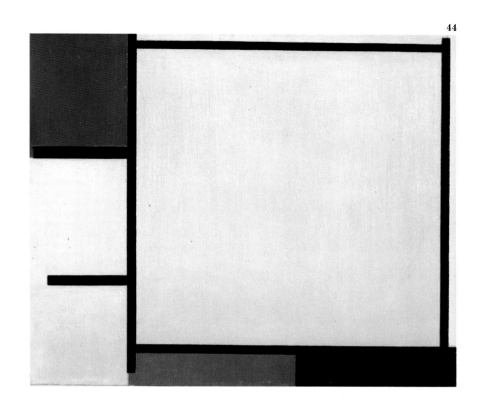

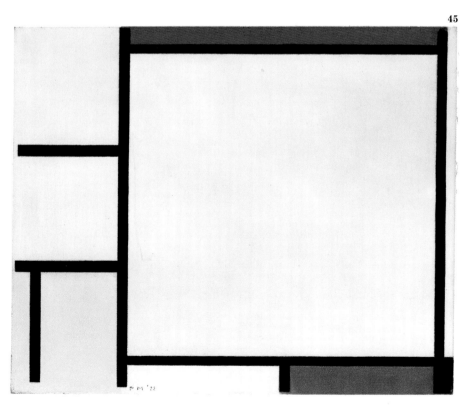

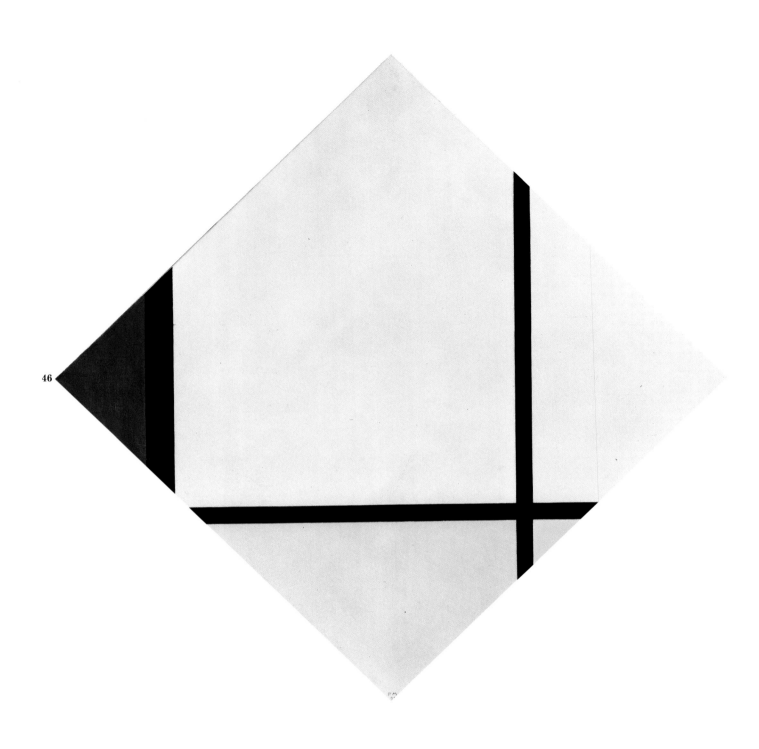

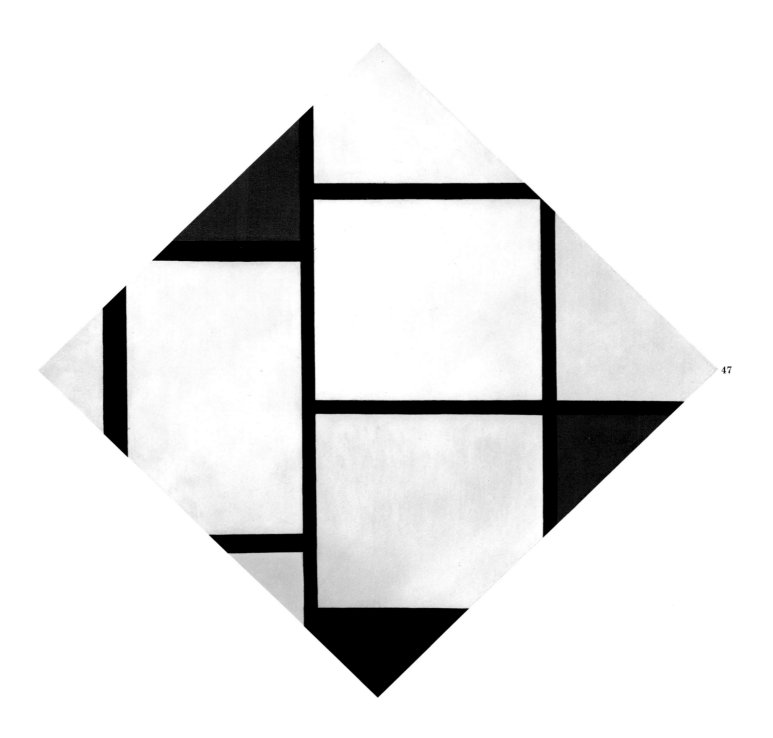

46, 47 Lozenge Composition with Three Lines and
Blue, Gray, and Yellow, *1925.* Lozenge Composition
with Red, Gray, Blue, Yellow, and Black, *c. 1924–25.*
*The extension of the grid all the way to the borders of
the painting, as well as the orientation of the works,
makes these paintings seem to be two fragments
selected by the artist from a larger, limitless grid.
Colors are applied in an exceedingly austere manner
since, as Mondrian himself stated, balance is
generally achieved by "associating a large surface
of non-color with a much smaller one of either color
or matter."*

48

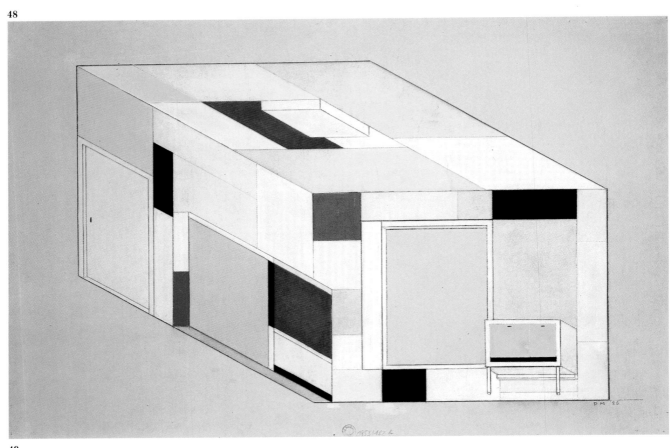

49

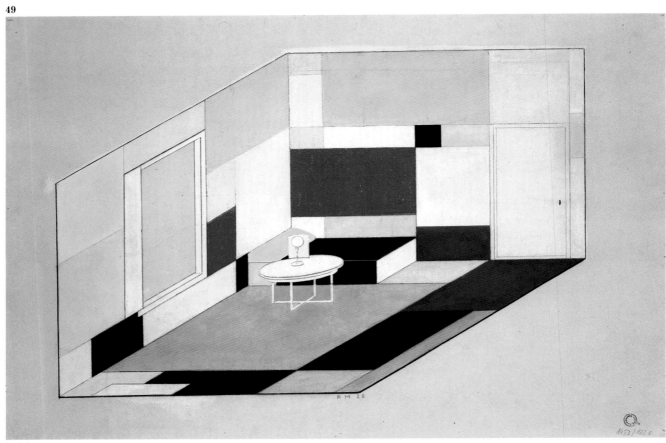

48, 49 Salon for Ida Bienert, Dresden, *box plan and isometric perspective, 1926.*
Believing that it was necessary to integrate all the arts, the artists of the De Stijl
*group—Van Doesburg more than anybody else—translated their own designs into the
architectural realm. Mondrian's contributions in this field, however, were rather
meager, possibly because his first such undertaking—the private parlor shown in these
gouache and ink drawings—was never executed.*

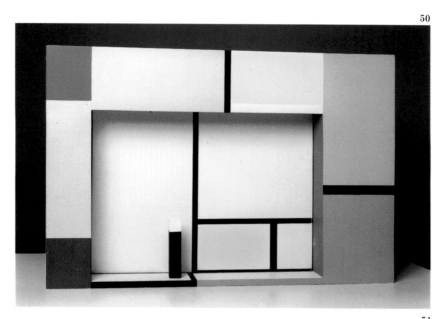

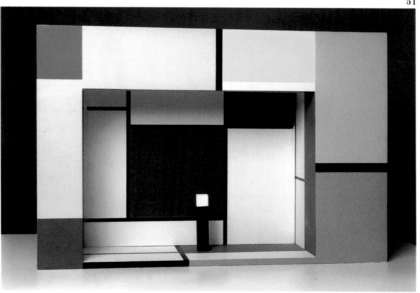

50, 51 *Maquette of the stage set for Michel Seuphor's* L'Ephémère est éternel, *1926,
showing two of the three interchangeable backdrops. Mondrian's sole creative foray
into the theater world was to design this set for a Futurist play by his friend Michel
Seuphor, which, however, was not staged during the painter's lifetime. The spareness
of Mondrian's design would have contrasted markedly with the syncopated character
of the play, whose topic was quite unconventional and which called for a multitude
of actors. In each of the acts of the play, the backdrop changed, as did the position of
the black and white oblong, which was intended to be moved around the set.*

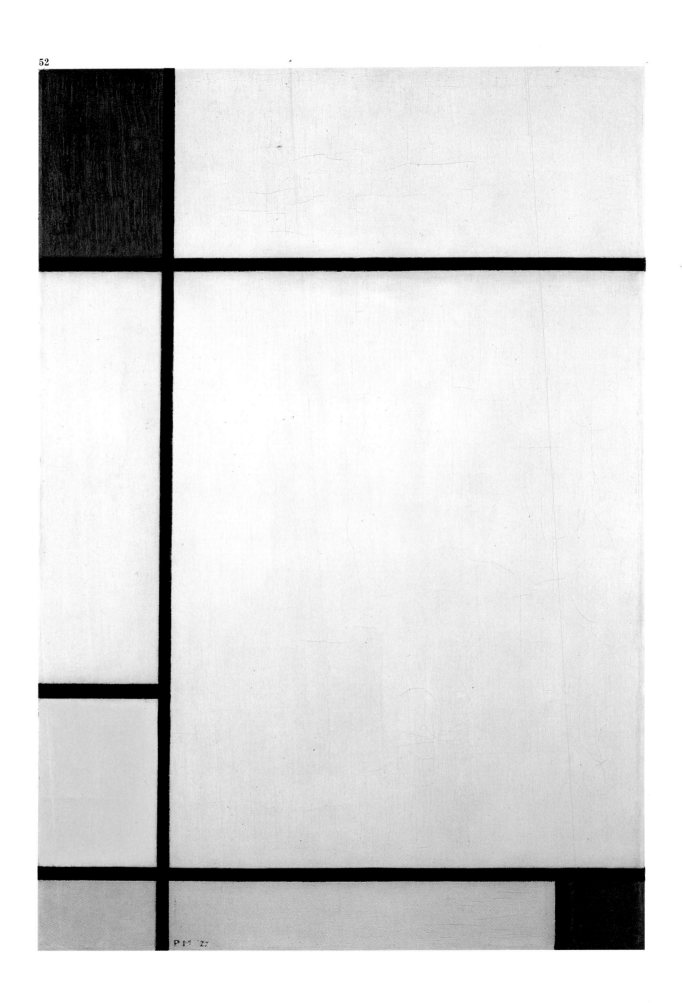

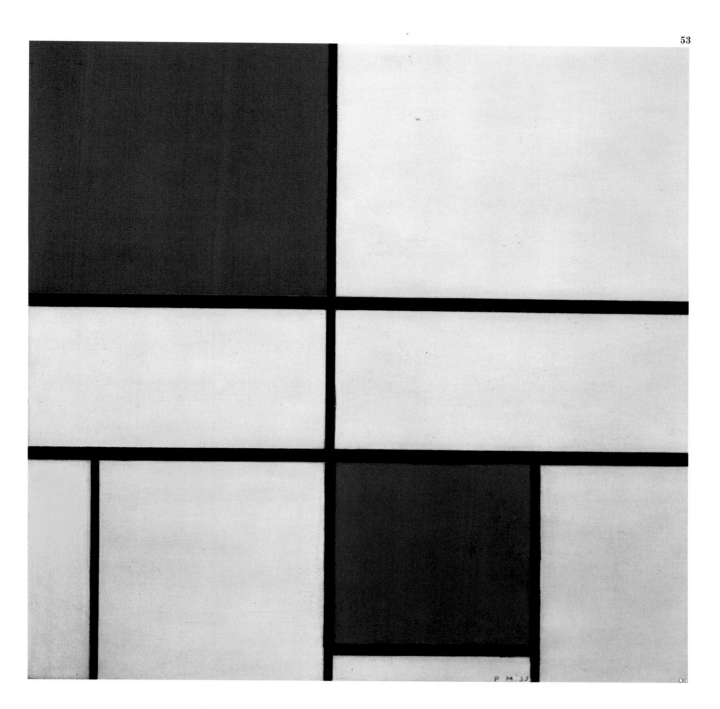

52, 53 Composition with Red, Yellow, and Blue, *1927*. Composition with Red, Yellow, and Blue, *1935. While Mondrian did not make systematic use of blue, red, and yellow until the early 1920s, in a text published in* De Stijl *in January 1918—quoting the Theosophist Schoenmaekers—he had already argued in favor of the necessity to limit oneself "to the three primary colors, along with white, black, and gray." For the artist, "in real-abstract painting, primary colors merely signify that colors act as basic colors. Therefore, primary colors are only used in a relative manner; the essential thing is that colors be free of all individuality and individual sensations, and that they only express the composed feeling of the universal."*

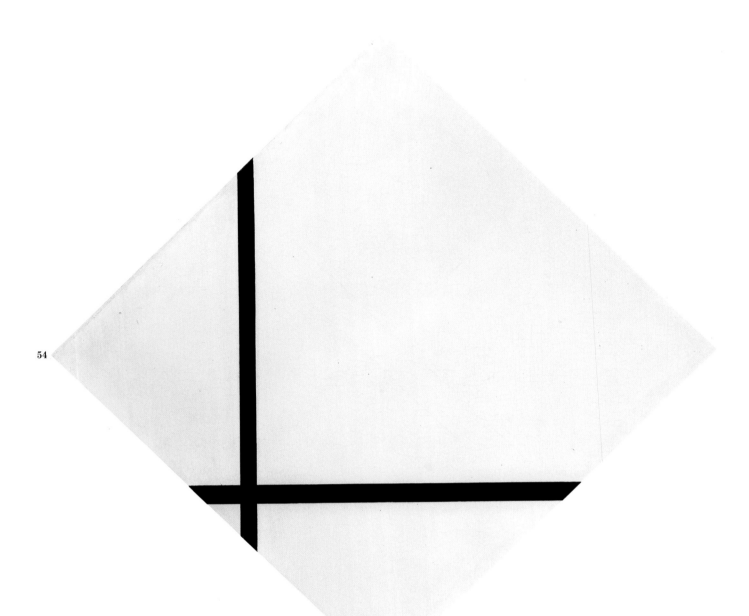

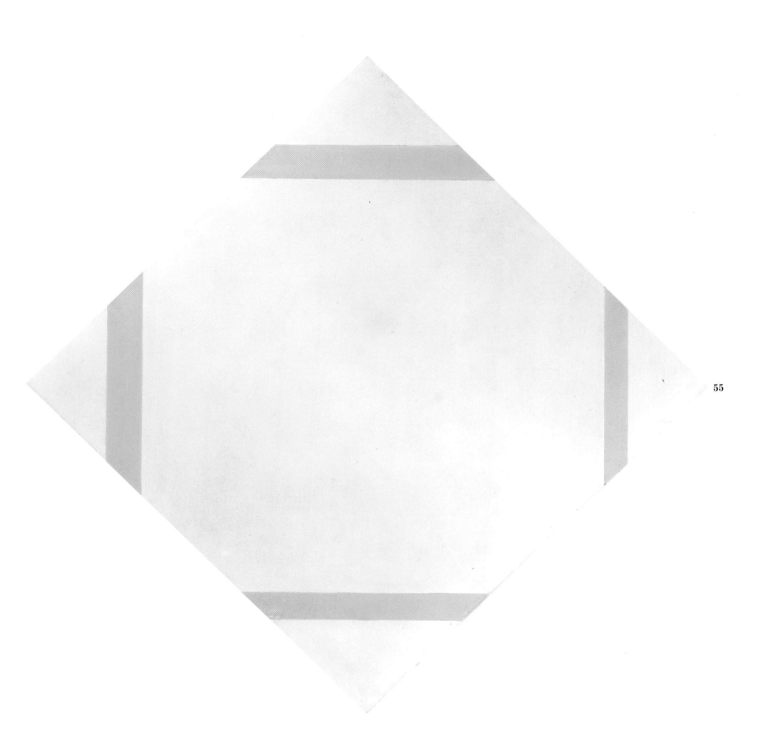

54, 55 Lozenge Composition with Two Black Lines, *1931*. Lozenge
Composition with Four Yellow Lines, *1933*. *The rigorous process
of restricting his artistic means that Mondrian initiated in 1922
culminated, during the first few years of the following decade, in
a number of paintings with only one color or only two non-colors.
Sometimes, as in* Lozenge Composition with Four Yellow Lines,
*a single color takes the place of black in the orthogonal lines.
The artist was now striving to achieve balance in the simplest
possible form.*

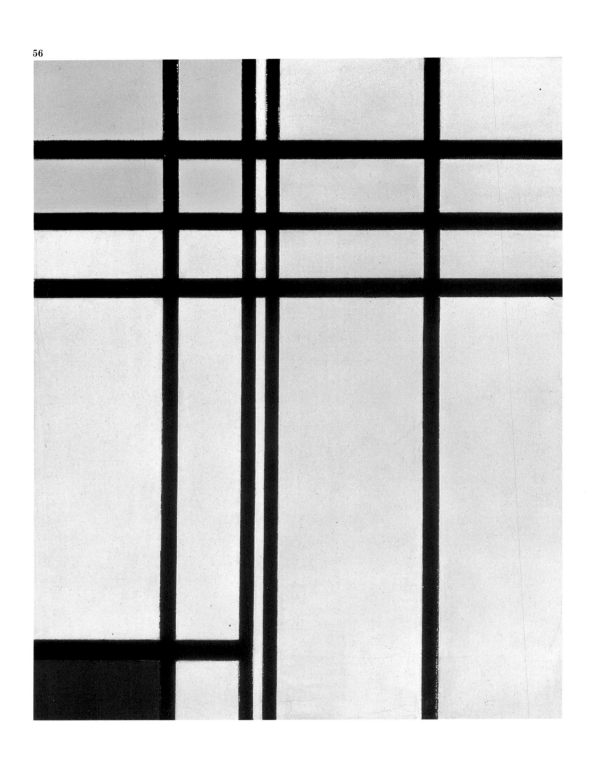

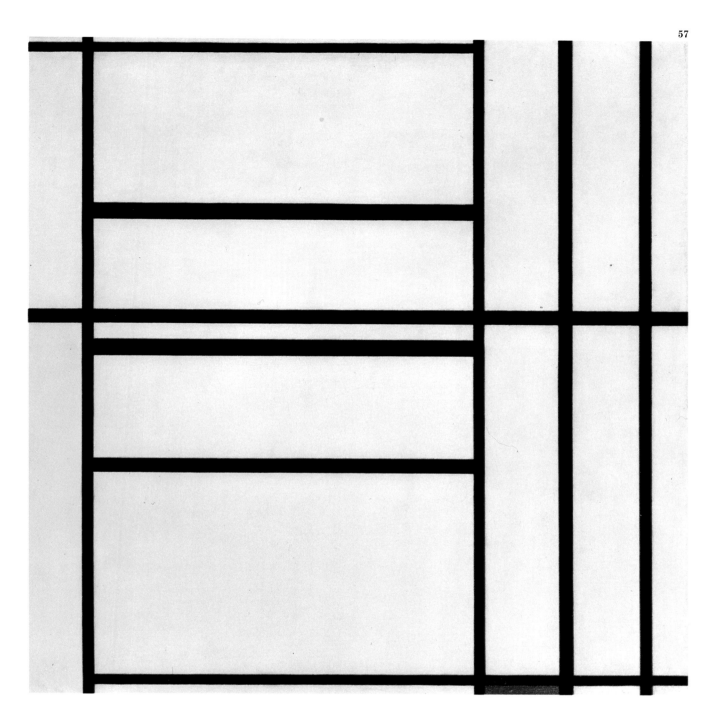

56, 57 Opposition of Lines of Red and Yellow, No. I, *1937.*
Composition with Red, *1939. As the 1930s drew to a close, colors
occupied progressively less and less space in Mondrian's
paintings, while the grid of horizontal and vertical lines gained
increasing density. Tracing a parallel between Mondrian's art and
his personal life may be a treacherous enterprise; nonetheless,
some authors have viewed the supremacy of the rigid and invariable
lines over the vital and more natural colors as a reflection of the
hardships that the painter was experiencing at the time.*

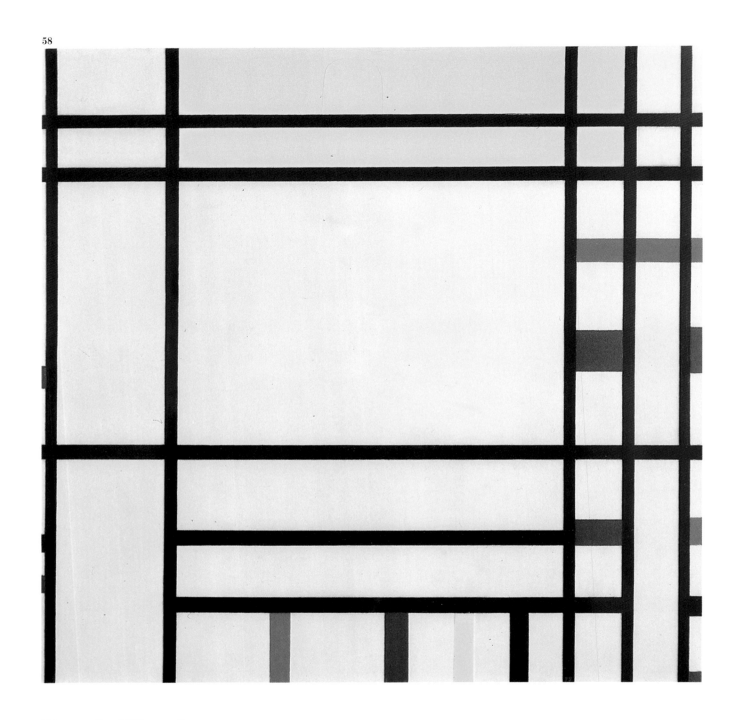

Boogie-Woogie

Mondrian experienced a profound feeling of freedom and release when he left London, where the Blitz had begun, in the autumn of 1940 and arrived in New York. With his new mood came a fresh attitude toward color. In a number of works of the preceding decade, color had begun to gain some independence from the network of lines in his paintings. Now it would quickly overpower black in the lines of the grid pattern, giving rise to a vibrant mosaic of minute patches. As is suggested by their titles, the works that Mondrian painted in America are much more than a stylized evocation of the myriad lights of New York City: they also express the fascination exerted on him by the syncopated rhythms of such typically American music as jazz and blues.

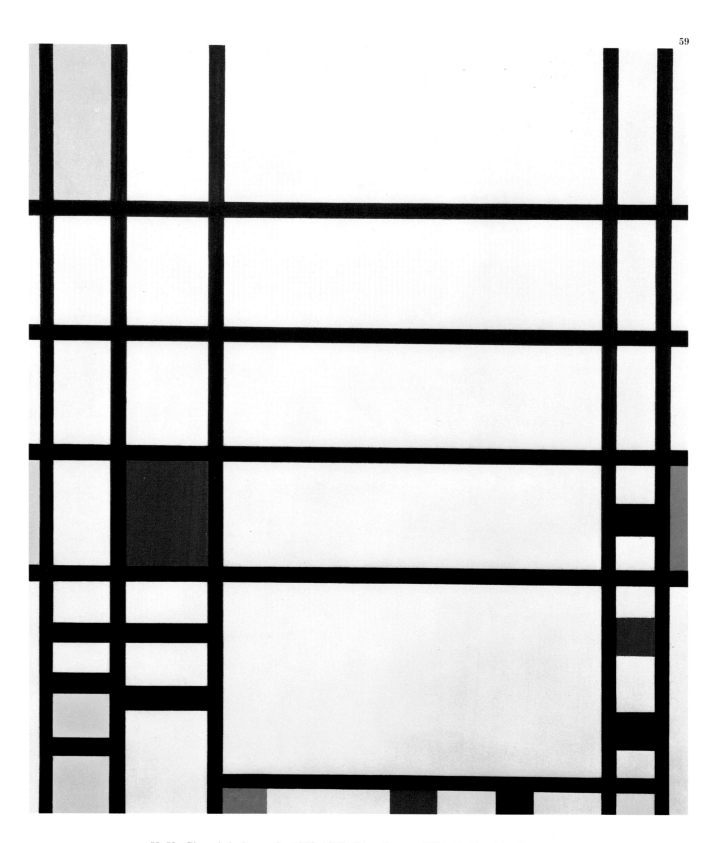

58, 59 Place de la Concorde, *1938–43*. Trafalgar Square, *1939–43. Mondrian began working on these two paintings during his stay in England and completed them four years later in the United States. They are typical of his production from the late 1930s in that the color patches are small in size and the compositions are dominated by a grid of black lines. But both paintings also have a new feature that the artist may have introduced after the compositions were established. Certain color patches are only partially delimited by black lines, suggesting—though with Mondrian's work one must be cautious with interpretation—a metaphor for freedom regained.*

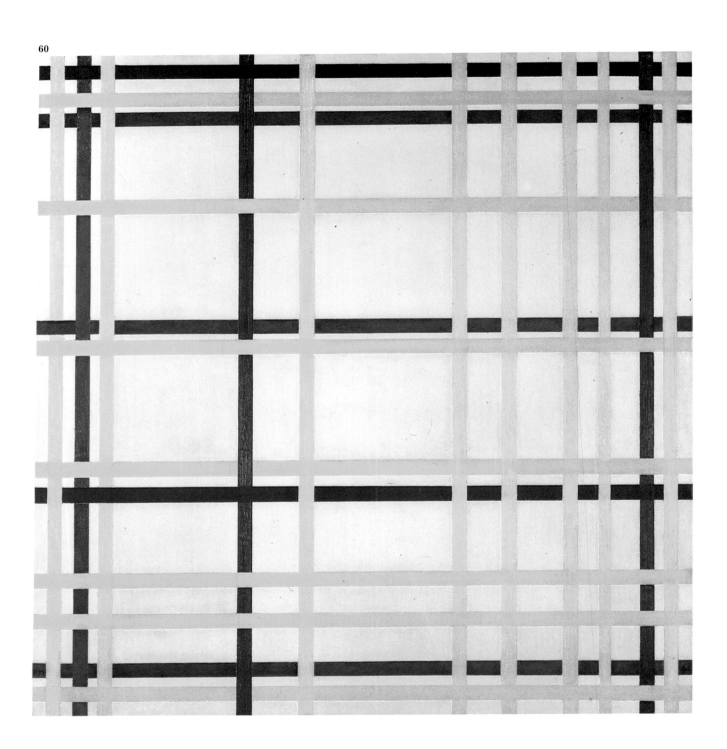

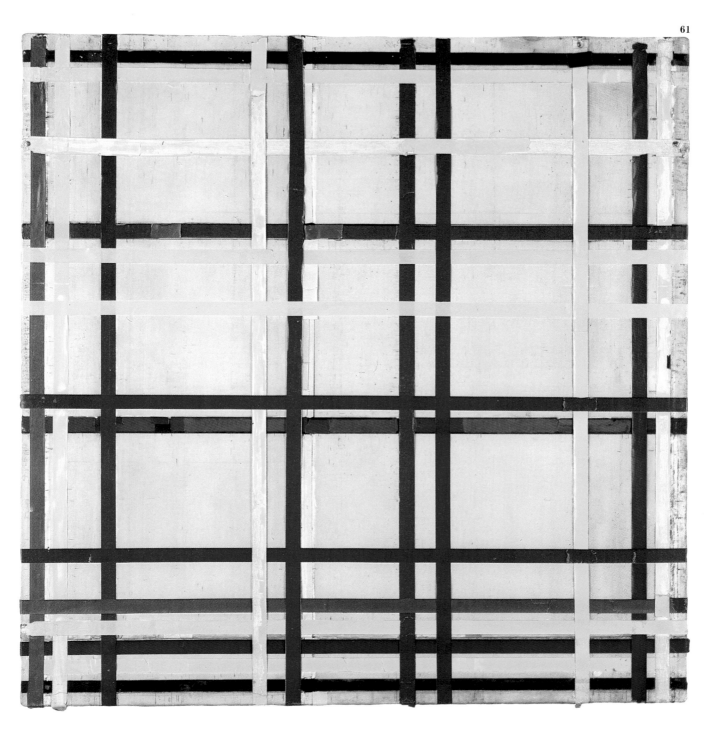

60, 61 New York City (New York City I), *1942.* New York City II, *1942–44 (unfinished). Most of the European artists who emigrated to the United States during World War II were struck by the country's vitality, and some, like Fernand Léger and Mondrian, were able to introduce the spirit of American dynamism into their work. Mondrian eliminated his typical black grid and replaced it with interwoven stripes of red, yellow, and blue. In New York, the artist discovered a product that he found useful in planning his pictures—paper tape in different colors. In the unfinished picture* New York City II, *some of the lines are painted, but the position of others is indicated by tape.*

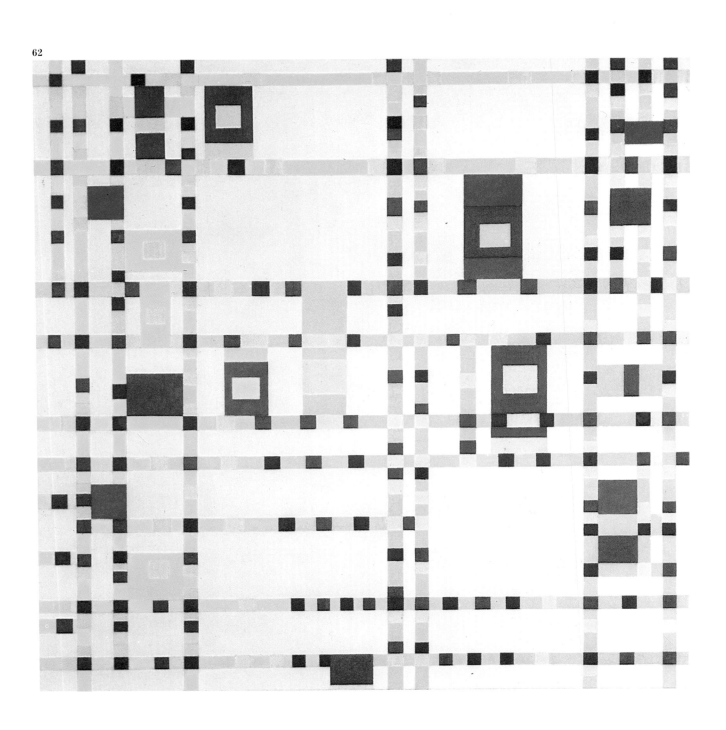

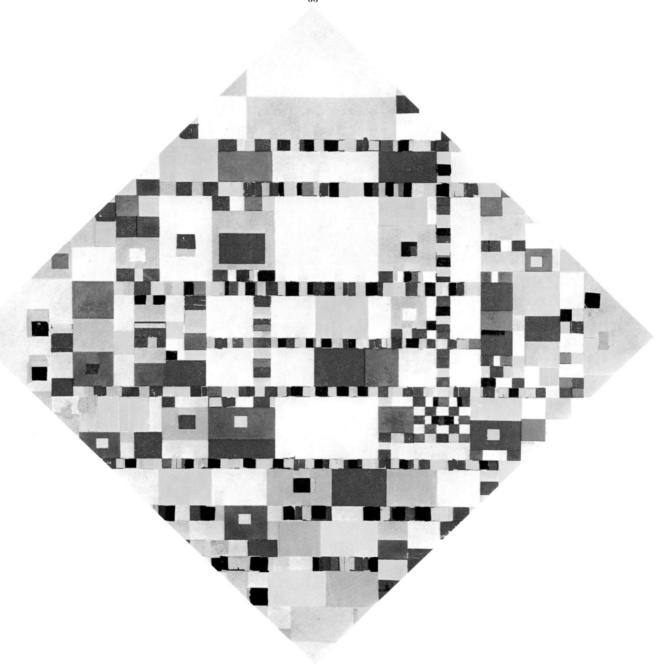

62, 63 Broadway Boogie-Woogie, *1942–43.* Victory Boogie-Woogie,
*1942–44 (unfinished). The titles of Mondrian's last two works,
illustrated here, refer to a type of jazz that was very popular in
New York, where the painter was then residing. Mondrian—who,
in 1927, had already titled one of his works* Foxtrot—*once
expressed himself in terms that indicate how close in his mind
were the mediums of music and painting: "In modern dance,
curved lines have yielded to straight lines, and each movement is
immediately neutralized by a countermovement, which amounts
to a quest for equilibrium."*

List of Plates

1 Solitary House, *1898–1900. Watercolor and gouache, 18 × 23" (45.5 × 58.5 cm). Haags Gemeentemuseum, The Hague*

2 Beech Forest, *c. 1898–99. Watercolor and gouache on paper, 17⁷/₈ × 22³/₈" (45.3 × 56.7 cm). Haags Gemeentemuseum, The Hague*

3 Boat on the Amstel at Sunset, *1900–1902. Watercolor and pencil, 21⁵/₈ × 26" (55 × 66 cm). Haags Gemeentemuseum, The Hague*

4 Little Girl, *1900–1901. Oil on canvas, 20⁷/₈ × 17³/₈" (53 × 44 cm). Haags Gemeentemuseum, The Hague*

5 Nistelrode Farm, *1904–5. Watercolor, 17⁵/₈ × 24³/₈" (44.5 × 63 cm). Haags Gemeentemuseum, The Hague*

6 A Stable at Sunset, *1906. Charcoal, pencil, and watercolor, 29¹/₈ × 38⁵/₈" (74 × 98 cm). Haags Gemeentemuseum, The Hague*

7 Landscape with Red Cloud, *1907. Oil on canvas, 21⁵/₈ × 26" (55 × 66 cm). Haags Gemeentemuseum, The Hague*

8 Trees on the Gein: Moonrise, *1908. Oil on canvas, 31¹/₈ × 36³/₈" (79 × 92.5 cm). Haags Gemeentemuseum, The Hague*

9 Trees on the Gein: Moonrise, *1907–8. Charcoal, 24³/₄ × 29¹/₂" (63 × 75 cm). Haags Gemeentemuseum, The Hague*

10 Windmill, *1907–8. Oil on canvas, 39³/₈ × 37¹/₈" (100 × 94.5 cm). Stedelijk Museum, Amsterdam*

11 Windmill at Sunset, *1908. Oil on canvas, 40¹/₂ × 33⁷/₈" (103 × 86 cm). Haags Gemeentemuseum, The Hague*

12 Windmill in Sunlight, *1908. Oil on canvas, 44⁷/₈ × 30¹/₄" (114 × 87 cm). Haags Gemeentemuseum, The Hague*

13 Blue Tree, *c. 1908. Tempera on cardboard, 29³/₄ × 39¹/₈" (75.5 × 99.5 cm). Haags Gemeentemuseum, The Hague*

14 Red Tree, *1908. Oil on canvas, 27¹/₂ × 39" (70 × 99 cm). Haags Gemeentemuseum, The Hague*

15 Woods near Oele, *1908. Oil on canvas, 50³/₈ × 62¹/₈" (128 × 158 cm). Haags Gemeentemuseum, The Hague*

16 The Tree, *1908. Oil on canvas, 42⁷/₈ × 28³/₈" (109.2 × 72.4 cm). Marian Koogler McNay Art Museum, San Antonio, Texas. Gift of Alice Hanszen*

17 Dune II, *1909. Oil on canvas, 14³/₄ × 18¹/₄" (37.5 × 46.5 cm). Haags Gemeentemuseum, The Hague*

18 Dune IV, *1909. Oil on cardboard, 13 × 18¹/₈" (33 × 46 cm). Haags Gemeentemuseum, The Hague*

19 Evolution, *1910–11. Oil on canvas, triptych, 70¹/₈ × 33¹/₂"; 72 × 34³/₈"; 70¹/₈ × 33¹/₂" (178 × 85 cm; 183 × 87.5 cm; 178 × 85 cm). Haags Gemeentemuseum, The Hague*

20 Dune Landscape, *1911. Oil on canvas, 55¹/₂ × 94¹/₈" (141 × 239 cm). Haags Gemeentemuseum, The Hague*

21 Church at Domburg, *1910–11. Oil on canvas, 44⁷/₈ × 29¹/₂" (114 × 75 cm). Haags Gemeentemuseum, The Hague*

22 Red Windmill at Domburg, *1911. Oil on canvas, 59 × 33⁷/₈" (150 × 86 cm). Haags Gemeentemuseum, The Hague*

23 Still Life with Gingerpot I, *1911. Oil on canvas, 25³/₄ × 29¹/₂" (65.5 × 75 cm). Haags Gemeentemuseum, The Hague (on loan to The Solomon R. Guggenheim Museum, New York)*

24 Still Life with Gingerpot II, *1912. Oil on canvas, 36 × 47¹/₄" (91.5 × 120 cm). Haags Gemeentemuseum, The Hague (on loan to The Solomon R. Guggenheim Museum, New York)*

25 Nude, *1912. Oil on canvas, 55¹/₈ × 38⁵/₈" (140 × 98 cm). Haags Gemeentemuseum, The Hague*

26 Landscape with Trees, *1912. Oil on canvas, 47¹/₄ × 39³/₈" (120 × 100 cm). Haags Gemeentemuseum, The Hague*

27 The Trees, *1912. Oil on canvas, 37 × 27¹/₂" (94 × 69.8 cm). The Carnegie Museum of Art, Pittsburgh; Patrons Art Fund, 1961*

28 Composition Trees II, *c. 1912–13. Oil on canvas, 38⁵/₈ × 25⁵/₈" (98 × 65 cm). Haags Gemeentemuseum, The Hague*

29 Composition in Line and Color, *1913. Oil on canvas, 34⁵/₈ × 45¹/₄" (88 × 115 cm). Kröller-Müller Museum, Otterlo*

30 Composition No. VII, *1913. Oil on canvas, 41 × 44⁵/₈" (104.4 × 113.5 cm). The Solomon R. Guggenheim Foundation, New York. Photo: David Heald; © The Solomon R. Guggenheim Foundation, New York*

31 Oval Composition III, *1914. Oil on canvas, 55¹/₈ × 39³/₄" (140 × 101 cm). Stedelijk Museum, Amsterdam*

32 Composition in Oval with Color Planes 2, *1914. Oil on canvas, 44¹/₂ × 33¹/₄" (113 × 84.5 cm). Haags Gemeentemuseum, The Hague*

33 Composition 10 in Black and White, *1915. Oil on canvas, 33¹/₂ × 42¹/₂" (85 × 108 cm). Kröller-Müller Museum, Otterlo*

34 Composition in Line, *1917. Oil on canvas, 42¹/₂ × 42¹/₂" (108 × 108 cm). Kröller-Müller Museum, Otterlo*

35 Composition in Color A, *1917. Oil on canvas, 19⁵/₈ × 17³/₈" (50 × 44 cm). Kröller-Müller Museum, Otterlo*

36 Composition with Color Planes 3, *1917. Oil on canvas, 18⁷/₈ × 24" (48 × 61 cm). Haags Gemeentemuseum, The Hague*

37 Composition with Grid 7 (Lozenge), *1919. Oil on canvas, vertical axis (irregular) 27¹/₈" (69 cm). Kröller-Müller Museum, Otterlo*

38 Composition with Grid 4 (Lozenge), *1919. Oil on canvas, vertical axis (irregular) 33½" (85 cm). Philadelphia Museum of Art. The Louise and Walter Arensberg Collection*

39 Composition with Grid 9 (Checkerboard with Light Colors), *1919. Oil on canvas, 33⅞ × 41¾" (86 × 106 cm). Haags Gemeentemuseum, The Hague*

40. Composition with Grid 6, *1919. Oil on canvas, 19¼ × 19¼" (49 × 49 cm). Öffentliche Kunstsammlung Basel, Kunstmuseum. Gift of Marguerite Arp-Hagenbach, 1968. Photo: Margin Bohler*

41 Composition A, *1920. Oil on canvas, 36 × 36¼" (91.5 × 92 cm). Galleria Nazionale d'Arte Moderna e Contemporanea, Rome*

42 Composition with Black, Red, Gray, Yellow, and Blue, *1921. Oil on canvas, 38 × 23¾" (96 × 60.5 cm). Museum Ludwig, Cologne. Photo: Rheinisches Bildarchiv, Cologne*

43 Composition with a Large Blue Plane, Red, Black, Yellow, and Gray, *1921. Oil on canvas, 23¾ × 19⅝" (60.5 × 50 cm). Dallas Museum of Art, Foundation for the Arts Collection. Gift of Mrs. James H. Clark*

44 Composition with Blue, Yellow, Red, Black, and Gray, *1922. Oil on canvas, 16½ × 19¼" (42 × 49 cm). Stedelijk Museum, Amsterdam*

45 Composition with Blue, Yellow, Red, and Black, *1922. Oil on canvas, 16½ × 19¼" (42 × 49 cm). The Minneapolis Institute of Arts, Minneapolis. Gift of Bruce B. Dayton*

46 Lozenge Composition with Three Lines and Blue, Gray, and Yellow, *1925. Oil on canvas, vertical axis 44⅛" (112 cm). Kunsthaus, Zürich. Vereinigung Zürcher Kunstfreunde*

47 Lozenge Composition with Red, Gray, Blue, Yellow, and Black, *c. 1924–25. Oil on canvas, vertical axis (irregular) 56¼" (142.8 cm). National Gallery of Art, Washington, D.C. Gift of Herbert and Nannette Rothschild*

48 Salon for Ida Bienert, Dresden, *box plan, 1926. Ink and gouache, 27⅞ × 27⅝" (70.5 × 70 cm). Staatliche Kunstsammlungen, Dresden*

49 Salon for Ida Bienert, Dresden, *isometric perspective, 1926. Ink and gouache, 14⅝ × 22½" (37.5 × 57 cm). Staatliche Kunstsammlungen, Dresden*

50, 51 *Maquette of the stage set for Michel Seuphor's* L'Ephémère est éternel, *1926. (Reconstruction: Ad Dekkers, 1964.) Paint on canvas; wood and cardboard, 20⅞ × 30 × 10½" (53.3 × 76.5 × 26.5 cm). Stedelijk Van Abbemuseum, Eindhoven*

52 Composition with Red, Yellow, and Blue, *1927. Oil on canvas, 23⅛ × 15¾" (60 × 40 cm). Stedelijk Museum, Amsterdam*

53 Composition with Red, Yellow, and Blue, *1935. Oil on canvas, 22 × 21⅝" (56 × 55 cm). Tate Gallery, London*

54 Lozenge Composition with Two Black Lines, *1931. Oil on canvas, vertical axis 44⅛" (112 cm). Stedelijk Museum, Amsterdam*

55 Lozenge Composition with Four Yellow Lines, *1933. Oil on canvas, vertical axis 44½" (113 cm). Haags Gemeentemuseum, The Hague*

56 Opposition of Lines of Red and Yellow, No. I, *1937. Oil on canvas, 17⅛ × 13¼" (43.5 × 33.5 cm). Philadelphia Museum of Art. The A. E. Gallatin Collection*

57 Composition with Red, *1939. Oil on canvas, 41⅜ × 40¼" (105.2 × 102.3 cm). Collection Peggy Guggenheim, Venice. Photo: David Heald; © The Solomon R. Guggenheim Foundation*

58 Place de la Concorde, *1938–43. Oil on canvas, 37 × 37⅜" (94 × 95 cm). Dallas Museum of Art, Foundation for the Arts Collection. Gift of James H. and Lillian Clark Foundation*

59 Trafalgar Square, *1939–43. Oil on canvas, 57¼ × 47¼" (145.5 × 120 cm). Collection The Museum of Modern Art, New York. Gift of Mr. and Mrs. William A. M. Burden, 1964. Photo © The Museum of Modern Art, New York*

60 New York City (New York City I), *1942. Oil on canvas, 46⅞ × 44⅞" (119 × 114 cm). Musée National d'Art Moderne, Centre Georges Pompidou, Paris*

61 New York City II, *1942–44. Oil on canvas with colored tape, 46⅞ × 44⅞" (119.4 × 114.3 cm). Kunstsammlung Nordrhein-Westfalen, Düsseldorf*

62 Broadway Boogie-Woogie, *1942–43. Oil on canvas, 50 × 50" (127 × 127 cm). Collection The Museum of Modern Art, New York. Given anonymously. Photo © The Museum of Modern Art, New York*

63 Victory Boogie-Woogie, *1942–44 (unfinished). Oil and paper on canvas, vertical axis 70½" (179 cm). Private collection*

Selected Bibliography

Blotkamp, Carel. *Mondrian: The Art of Destruction.* New York: Harry N. Abrams, 1994.

Bois, Yve-Alain, ed. *L'atelier de Mondrian.* Paris: Macula, 1982.

Bois, Yve-Alain, et al. *Piet Mondrian.* Boston, New York, Toronto, and London: Little, Brown, 1994.

Elgar, Frank. *Mondrian.* New York, Washington, and London: Praeger Publishers, 1968.

Faucherau, Serge. *Mondrian y la utopía neoplástica.* Barcelona: Ediciones Polígrafa, 1994.

Jaffé, H. L. C. *Piet Mondrian.* Paris: Cercle d'Art, 1991.

Piet Mondrian: Centennial Exhibition. New York: Solomon R. Guggenheim Museum, 1971.

Seuphor, Michel. *Piet Mondrian, sa vie, son oeuvre.* Paris: Flammarion, 1986.

Series Coordinator, English-language edition: Ellen Rosefsky Cohen
Editor, English-language edition: Ellyn Childs Allison
Designer, English-language edition: Judith Michael

Library of Congress Catalog Card Number:
ISBN 0–8109–4687–4

Printed and bound in Spain by La Polígrafa, S.L.
Parets del Vallès (Barcelona)
Dep. Leg.: 35.274 - 1996